Pro Techniques of
WEDDING
PHOTOGRAPHY

Published by HPBooks
A Division of Price Stern Sloan, Inc.
360 North La Cienega Boulevard
Los Angeles, California 90048

© 1989 Price Stern Sloan, Inc.
Printed in U.S.A.
10 9 8 7 6 5 4 3 2

NOTICE: The information contained in this book is true and complete to the best of our knowledge. All recommendations are made without any guarantees on the part of Price Stern Sloan. The authors and publisher disclaim all liability in connection with the use of this information.

Library of Congress Cataloging-in-Publication Data

Hurth, Robert.
 Pro techniques of wedding photography.

 1. Wedding photography. I. Hurth, Sheila.
II. Title.
TR819.H87 778.9'93925 87-31237
ISBN 0-89586-632-3

Pro Techniques of

WEDDING
PHOTOGRAPHY

by
Robert & Sheila Hurth

HPBooks
a division of
PRICE STERN SLOAN
Los Angeles

Contents

Foreword

In recent years, wedding photography has become increasingly specialized and lucrative. A province that was once wide open to the casual shooter is now the true domain of those who can convincingly demonstrate their skill and dedication, be they professional photographers or serious amateurs.

Up to now, few books have appeared that discuss in detail all the facets of wedding photography. The book you are about to read, authored by my two friends Sheila and Robert Hurth, represents a true breakthrough. It is loaded with information that can benefit amateur and seasoned professional alike.

The Hurths are a wonderful example of how a true love of photography, coupled with hard work, can lead to sensational success. I have delighted in watching their growth and development over the years. Their secret is a simple one: A constant quest for excellence, an unceasing search for new techniques, tireless study, and practice, practice, and more practice!

In a few short years, the authors have transformed a modest studio in Fort Lauderdale into a dynamic, award-winning and profitable organization of which both our community and profession can be proud.

As a natural extension of Robert and Sheila's work, this book is not a surprising development. Enthusiasm and energy such as the Hurths' is hard to contain. It demands to get out and be shared! May you enjoy sharing their experiences, and benefit from their teaching.

Sterling A. Clarke
Director of Photography
Art Institute of Fort Lauderdale
Fort Lauderdale, Florida

Introduction

Marriages are back in vogue! The number of weddings taking place is increasing year by year. With this, there's an increasing demand for good, competently executed and creative wedding photography.

Not many years ago, it was common for a bridal couple to hire a photographer to shoot two or three dozen shots of their entire wedding and end up with a bridal book containing no more than 12 to 24 photos. The photography was usually of only moderate quality. At that time, a photographer generally considered weddings as a sideline to his main photographic business. The wedding photographer was not a specialist.

Gradually, this type of photography began to change, and it's still changing. Today, wedding photography is the province of the knowledgeable and appropriately equipped specialist.

Some professionals don't want to get involved with wedding photography, for a whole host of reasons. The hours are long, weekends are always involved and the work is hard.

In contrast, many amateurs venture forth where "angels" often fear to tread. Many of these people think that all you have to do is have a camera—of any kind—set it to automatic, follow the bridal couple around and shoot a few rolls of film. You produce a few candid shots and, presto, quick and easy money is the result.

There are good and bad wedding photographers, whether they be amateurs or professionals. This book is directed at all who want to become better wedding photographers—pros and amateurs alike.

Although the authors of this book have both been involved in photography for about 15 years, until about six years ago we had only photographed six or so small weddings. We did not do them well.

Then our lives changed: We purchased a small studio in Fort Lauderdale, Florida. It had been a two-man operation with only a modest shooting area and grossing about $70,000 per year.

One of the first bookings we got at our newly acquired studio was a wedding. It was a rather sizable affair: 200 guests; 14 people in the bridal party; dozens of family members, all of whom wanted their photos taken with the bridal couple. The whole thing lasted eight hours.

The results of that wedding were no more successful than had been our earlier attempts. We did not have the experience to deal with all of the situations that confronted us. Equipment failed; we didn't know how to take charge and "direct" the people in front of our cameras; we were unfamiliar with posing and lighting techniques; we didn't even realize that wedding photography must follow an orderly progression.

As a result of this fiasco, we began a deliberate plan to study with anyone we could find who had an established name as a wedding photographer. We became active in local, state and national photographic associations. We expended long hours and lots of money to learn the "dos" and "don'ts" of wedding photography.

That was five years ago. Last year we shot about 240 weddings and grossed about $500,000. We now occupy almost an entire building and our studio's shooting area alone covers approximately 4,000 square feet. We have nine full-time and three part-time employees—and we're still growing.

Although we do other forms of photography, including creative portraiture, commercial work, fashion, glamour, and boudoir photography, we owe a great part of our overall success to our wedding photography.

Incidentally, wedding photography introduces us to a lot of people, which automatically leads us to other forms of photographic assignments.

We wrote this book to save aspiring wedding photographers time, effort, money and embarrassment, and to help ensure that their wedding photography brings them success and satisfaction. We can promise you one thing: Contrary to our initial impression some years ago, wedding photography is a fabulous field. So, read on!

Insight To A Wedding

There's much more to a wedding than the usual facets that have become symbolic of the event, such as a church ceremony, music, flowers, food—and even photographs. A wedding is a very special event involving *people*. It's the personal and emotional interaction of a bride and groom with family members and friends that makes a wedding day a special event.

Occasionally, you'll find a bride who is so well organized that all of the wedding day's events unfold smoothly. However, this is the exception rather than the rule. Most weddings depend on the professional services of a caterer, a band and a florist. The bride trusts that all of them will perform their duties correctly and in a timely manner. Unfortunately, things don't always run that smoothly.

To take great photos, a wedding photographer must be totally familiar with all aspects of the event. He must also be able to direct the "cast of characters" that will appear before his camera during that very special "performance." That's why you will find that a good wedding photographer, who knows the event like the back of his hand, often is the single most helpful person in making *all* the events of that day come together in an orderly progression.

THE PHOTOGRAPHER MUST TAKE CHARGE

A wedding photographer must always be prepared to take charge. He must have the events of the day unfold in a way that is consistent with his photographic purpose. The evidence of his success—or failure—is much more long-lived than that of the music, which dies away; of the food, which is consumed; or of the flowers, which wilt and are discarded. The photographs remain as permanent evidence.

If, at a reception, the band leader forgets to invite the bride to dance with her father, the photographer must arrange it and then photograph it. If the caterer places the bridal couple at the wedding-cake table in a way that is not conducive to good photography, the photographer must make the necessary changes.

Even while he takes charge, the photographer must keep a low profile. He must never be obtrusive or overbearing. He must know what he wants to do in advance and then do it—effectively, efficiently and quietly.

THE ANATOMY OF A WEDDING

The first requirement for a "fail-safe" system in wedding photography is a highly skilled and dedicated photographer who is also good at dealing with and directing people and—not least—who has an intimate knowledge of the "anatomy" of a wedding. The photographer must be totally familiar with all aspects of the event.

A wedding photographer is assigned a job that can be done once, and once only. He is relied upon to record, as creatively as possible, a few of the most important hours in the lives of a bridal couple. In this branch of photography, unlike many others, there's no chance for a reshoot. You can't go back and redo the job tomorrow because you failed yesterday.

Although there are many ways to shoot a wedding, and they'll vary from one photographer to another, there are certain basics and rules that run throughout almost all weddings. Learn these first. When you're totally familiar with your craft, you can afford breaking the rules and trying new and different things.

Before photographing a wedding, get detailed information from the bride about the events planned for every phase of her wedding. This will prevent your being caught unprepared.

Seven Phases of a Wedding—Just as it's good general advice to live one

day at a time, we recommend that a wedding photographer think of the integral *phases* of a wedding rather than of an entire wedding at one time. Doing the latter may appear too threatening and overwhelming.

The photography of a "love story" called a wedding will unfold in seven basic phases, each requiring a somewhat different approach. To help you shoot your weddings in an organized, manageable fashion, we spell out the seven phases here:

1. Formal and casual portrait photography of the bride, and of bride and groom together, in the studio and on location. This phase usually takes place before the wedding day.
2. The bride, and other members of the party, preparing to leave for the wedding ceremony.
3. Photography before, during and after the ceremony.
4. Following the ceremony, the subjects are asked to return to the altar for formal photography of the bridal couple, the bridal party and family groups. These shots are generally referred to as *altar returns*.
5. Exit scenario, consisting of photographs taken outside the church after the ceremony.
6. Romantic photographs of the bridal couple.
7. Photographs taken during the cocktail hour and reception—largely informal.

PHOTOGRAPHIC CATEGORIES FOR ALL THE WEDDING PHASES

In photographing the wedding phases, it will help if you confine your thinking to the following four major photographic categories:

Command Photographs—All of the photographs selected from the pink sheet (see accompanying illustration) should be of primary consideration. When a bride makes choices from this sheet, she is literally telling you what photographs she intends to buy. You cannot ignore this request.

Must-Get Photographs—This category includes all the photographs you must make to record properly any wedding. In this category you have little or no discretion. You should take the photographs whether they have been requested or not.

Suggested Photographs—From time to time and throughout the wedding day, the bride, groom and members of their families will suggest photographs for you to take. Respond to their requests as quickly as you can. These suggested images will be definite sellers.

Frosting Photographs—This category includes all other photographs possible during any phase of a wedding. These images are like the frosting on a cake. You make them if and when you can and if you think the circumstances merit them. They help to round out a bridal album so that it tells the love story of the wedding day.

Often a particular photograph will pertain to more than one category. It really doesn't matter. To ensure success, you must make the photographs included in categories 1 and 2 and you should make the photographs included in categories 3 and 4.

As you move through each phase of a wedding and as you are photographing, ask yourself how each of your shots is going to fit in as an integral part of the representation of the wedding day. If a shot is not representative but is just a pretty shot, you may be better off disregarding it and moving on to another photographic situation that will have a stronger meaning to the bridal couple and the families.

For example, taking a photo of the front of the church where the bridal couple were married is not likely to have much appeal. It's just a documentary shot of a building. However, if you take a shot of the bridal couple in front of that church—hand in hand, with him holding her close to him, looking tenderly into her eyes—you'll almost certainly have taken a winner.

Follow Current Styles—Styles in wedding photography have changed drastically in the last several years and the dedicated photographer must keep abreast of these changes. The best way to do this is to become familiar with the wedding photography of accomplished, modern photographers.

Avoid gimmicky shots, such as a bride and groom apparently located inside a brandy glass. This used to be popular but is not regarded as stylish or in the best of taste any longer.

Today, romance is back in vogue. The experienced wedding photographer must be prepared to give a bride romantic photos, often using soft window light and a soft-focus lens attachment. All poses should look natural, comfortable and totally uncontrived.

Romantic photos have far more appeal, and sales potential, than mundane shots in which the bridal couple is just standing stiffly, staring into the camera, blasted with light from an on-camera flash.

PHOTOGRAPH EMOTIONS

Always remember that you are not assigned or requested to take photos that are simply documentary records of an event. That could be done by anyone—family member or friend—who happens to have a camera. You can be sure that such photos will, in fact, be taken all around you while you do your own work.

You are at weddings specifically to photograph *feelings* and *emotions*. That's the real challenge: To record on film feelings of love, tenderness, togetherness. You must learn to "see" such images and to capture them on film. If the atmosphere you want is not present, you must use your directorial talents to generate them.

You will soon discover that not all bridal couples know how to display readily their romantic feelings in public. But don't waste your time or film by taking photos of the two of them just standing next to each other, staring awkwardly into the camera. Romantic photos are much more than this. They are more intimate. They strive to become reflections of the way the bridal couple *truly* feel about each other on their wedding day.

In front of a camera, most couples will not know exactly what to do or how to do it. You will have to take charge and show them. For example, stand the groom close to his bride. Let him cradle her face gently in his hands and then lower his face to hers so that their lips almost touch. You will now get that special look or gleam that you are after. Capture that on film.

The number of romantic shots you will take will vary. It will depend on the amount of time the couple affords you, the locale you are working in, and the couple's involvement with each other.

One thing we can tell you for certain: Take romantic shots. They are very popular and are a great addition to any bridal album. But, beware of overdoing it. You don't want the couple to tire or become bored with this phase of photography. You can avoid this by organizing your shooting so that you take romantic photos during various phases of the wedding. For example, take a few of them at the conclusion of the ceremony session, some before the reception starts, and additional ones at intervals during the reception. Spacing these shots, throughout the day, will help keep the interest of the couple from waning.

Above all, show your own enthusiasm when taking such photographs. It's contagious. The couple will become enthused with you. The result will show in your photos.

When taking romantic photos, you can let your creative juices run free:

Try soft focus, soft light, wide open *f*-stops for limited depth of field, different lens focal lengths for different perspective effects, loving poses, and so on.

WEDDING PHOTOGRAPHY REQUIRES DEDICATION

You don't have to be a 15-year veteran of photography to shoot a wedding successfully. We have seen many outstanding wedding photos that were shot by dedicated amateurs who had mastered the basics of photo technique. What made their work outstanding—and what makes the work of the professional outstanding, too—is dedication.

WEDDING PHOTOGRAPHY REQUIRES TECHNICAL COMPETENCE

A wedding is no time to stop and think about how your light meter works, how to connect your flash equipment, or how precisely to determine depth of field. Shooting a wedding dependably requires basic technical knowledge and competence. When the wedding day is over, the only tangible thing that the bridal couple and their respective families have are the photos that you have taken for them.

If you take an ordinary, everyday portrait and ruin it, the probable ramification will be a reshoot. At worst, you may have to refund a fee and possibly lose a customer. But if you ruin a set of wedding pictures because you did not know what to do, or because you did not take all the right shots, or because you didn't have the right equipment, you will have to face some very disappointed and angry clients. That's understandable, because there's no chance for a repeat performance, or a reshoot.

We're not trying to scare you, but simply to stress the importance of competence in wedding photography. Such photography is not the

province of the "happy-snapper" nor the "once-in-a-while" photographer whose only concern is to make a few fast dollars on the side. Weddings are the domain of dedicated photographers who strive for professionalism in all aspects of their work.

STEPS IN BECOMING A GOOD WEDDING PHOTOGRAPHER

Throughout this book, you will find tips and information that will help you become a better wedding photographer. Below are some recommendations that you may find particularly helpful:

● *Watch a Lot of Weddings:* First and foremost, go to as many weddings as you possibly can. This will afford you the opportunity of viewing actual ceremonies, even if it is from the sidelines or from the back of the church. Try to visit at least a dozen weddings before you think of taking on a wedding for yourself.

To make such visits, you need not be acquainted with the bride and groom. Churches and temples are generally open to the public. Seek out the official in charge of the church or temple and ask when weddings are scheduled.

Watch what the assigned professional photographers do and how they handle each situation. Make notes. Observe the bridal couple, the bridal party and the various family members and how they interact with each other and the photographer.

● *Attend Some Receptions:* Visit one or several of the better hotels or country clubs in your area. Inquire when wedding receptions are to take place and whether it might be possible to be present as an observer. Plan to observe about a dozen receptions "from the sidelines." Make notes on the progression of the phases of a reception and the role the photographer plays in achieving his purpose.

● *Assist a Wedding Photographer:* Become an assistant—without pay,

WEDDING DATE: _____
NAME: _____

Tiffany *Photographic*

<u>WEDDING CANDIDS</u>

On the list below, check off which special moments you would like
to see in your wedding album:

BEFORE THE CEREMONY:

__Bride in dress
__Bride with mother
__Bride with father
__Bride with both parents
__Bride with honor attendant
__Bride with maids
__Bride touching up makeup, hair
Other moments_____

__Bride at gift table
__Everyone getting flowers
__Bride leaving house
__Bride, father getting in car
__Groom alone
__Groom with best man
__Groomsmen getting boutonnieres

AT THE CEREMONY:

__Guests outside church
__Bride, father getting out of car
__Bride, father going into church
__Ushers escorting guests
__Groom's parents being seated
__Bride's mother being seated
__Soloist and organist
__Groom and groomsmen at alter
__Giving-away ceremony
__Alter or canopy during ceremony
__Bride and Groom exchanging vows
__Ring ceremony
__Bridesmaids coming down aisle

__Maid or matron of honor
__Flower girl and ring bearer
__Bride and father
__Groom meeting bride
__The kiss
__Bride and groom coming up aisle
__Bride and groom on church steps
__Bride alone in the chapel
__Bride and groom among guests
__Bride and groom getting in car
__Bride and groom in back seat of car
__Other ceremony moments

POSED SHOTS BEFORE THE RECEPTION:

__Bridesmaids looking at bride's ring
__Bride's and groom's hands
__Bride and groom together
__Bride with parents
__Groom with parents
__Bride and groom with honor attendants
__Bride and groom with children

__Bride with her attendants
__Groom with his attendants
__Bride, groom, all the wedding party
__Bride, groom, all the parents
__Other people with bride, groom

AT THE RECEPTION:

__Bride and groom arriving
__Bride and groom getting out of car
__Bride and groom going into reception
__The receiving line
__Buffet table
__Bride, groom at bride's table
__Parets' table
__Bride, groom dancing
__Bride, her father dancing
__Groom, his mother dancing
__The musicians
__Bride, groom talking to guests
__Passing the guest book
__The cake table

__Bride, groom cutting the cake
__Bride, groom feeding each other cake
__Bride, groom toasting
__Throwing and catching bouquet
__Groom taking off bride's garter
__Throwing, catching garter
__Wedding party decorating car
__Bride and groom ready to leave
__Guests throwing rice
__Bride and groom getting in car
__Rear of car speeding off
__Table shots
__Outside grounds (wedding party)
__Other reception fun

if necessary—to a local wedding photographer. This firsthand experience will prove invaluable.

● *Maintain a Professional Attitude:* When you start shooting weddings yourself, constantly maintain a proper attitude. Be courteous and considerate; be attentive to the bridal couple and their families. It will make your job go more smoothly, effectively and efficiently. Above all—always maintain a positive attitude.

● *Become Involved:* Become *involved* in each wedding you shoot. Don't merely *attend.* You may be a hired professional, a stranger, and an outsider. But you are also a very integral part of the event, and someone on whom much of its success depends.

● *Prepare a Check List:* Know the bridal couple's wishes. One of the ways we accomplish this is with our pink check list, reproduced here. At the time of booking a wedding, we supply the bride with such a sheet. We ask her to complete it and then set a meeting date with us at least two weeks before the wedding date. At this meeting we review the check list in detail.

The list and meeting accomplish many goals. They give us a final opportunity of becoming really well acquainted with the bride and learning which photos are most important to her.

A bride is free to add anything she wishes to the check list. This enables us to determine in advance any specific problems we may encounter. For example, a bride's parents may be divorced or separated and unwilling to be photographed together. Having this information prior to the wedding date may avoid embarrassment and also save time.

● *Take Emergency Equipment:* Camera and lighting equipment alone isn't enough. Take with you to each wedding a "fix-it" bag. It should include such ever-helpful items as bobby pins, clothespins, safety pins, a few strips of Velcro, needle and thread, face powder, paper tissues, scissors, and hairspray. You might include various items of makeup, and even smelling salts. Such items can be very helpful for anything from adjusting rented clothing that doesn't fit quite right to correcting a hairstyle or smudged makeup, or helping to revive a guest for whom the whole affair has become a little too much!

● *Dress Appropriately:* You are officiating at an event that is very important and that may be costing your clients several thousand dollars. To be perceived as the competent professional you are, you must dress appropriately. Dress in keeping with the type of affair you have been assigned to photograph. This does not mean that you must wear a tuxedo to every affair. It does mean that you should generally wear a dark suit, white shirt and tie to every evening affair that does not require a tuxedo.

● *Be Alert at All Times:* Be aware of all the occurrences at the event—both large and small. You must know what is going to happen and when, and also be prepared for the unexpected. For example, a bride may be dancing with one of her ushers when, suddenly, she trips over her own feet. Down she goes, laughing all the while. Shoot it! They'll love it!

At the cake table, the groom might be cutting a piece of cake to feed to his bride. As he places the piece gently to her mouth, he suddenly gets a different idea: He decides to get "cute" and pushes the whole piece into her face. Shoot the action! Everyone will love the photos!

● *Learn to Work With an Assistant:* You should not attempt to work without help, especially at large weddings. It's important to get used to working with an assistant. This will help to make your transitions from one photographic situation to another flow more smoothly and rapidly. At an important and lively event such as a wedding, people may become impatient and irritated if you take too long to set up and take a shot.

● *Show Self-Confidence:* Be efficient and confident when shooting. Take each photo decisively and without hesitation. Don't belabor the point by shooting the same situation five or six times over. If you do, the subjects will equate your indecisiveness with a lack of skill and you may lose their confidence—and cooperation.

The bridal couple, their families and the bridal party are all anxious to have fun. This usually means getting to the reception hall as quickly after the ceremony as possible. They want to be with their friends, drink, dance and "party." They want good and creative pictures—but they will not spend a lot of time posing while you seek that "just right" expression.

You may know seven different ways of taking a particular shot but, at a wedding, you're not likely to have the time to take them all. You will have to select the way you feel will best serve the purpose. If you have the time, by all means try another way, too.

● *Meet the Right People:* Know where to find help. When you arrive at the reception, introduce yourself to the master of ceremonies, band leader or disc jockey. Make sure he knows that you want to be informed of all the events that he intends to announce, prior to their actually happening. In a similar manner, introduce yourself to others who might be able to help make your job run smoothly.

● *Decline Drink or Food:* Our basic rules of wedding etiquette require that a hired photographer *never* consume alcoholic beverages when shooting a wedding. Even if the bride, groom and members of their families *insist* that you have something to drink, you must refuse. If you don't, it may come back to haunt you. If you have just *one* drink and later show the bride

and her family just *one* out-of-focus picture, they will swear—maybe not to you but to their friends—that all of their wedding photos were ruined because their photographer was intoxicated.

In like manner, never take food or be seated at a partially vacant guest table at a reception unless the bride, groom or her family have asked you to join them for dinner.

If you are invited to join the dinner party, you must still keep your camera close at hand and remain watchful for important photos to take. Remember that, first and foremost, you have been assigned an important job. Your first priority is to provide good and varied photos of the event.

Obviously, it's unreasonable to expect anyone to spend seven or eight hours working at a wedding without some form of nourishment. However, with all the things they have to think about, brides sometimes forget this. If we know that the wedding is going to last in excess of five hours, we inform the bride, at the time the wedding is booked, that she is responsible for providing food for the photographic team. Failing this, we charge an additional $50. However, in most cases the brides agree to provide food for our staff members.

PHOTOGRAPHIC COMPETITION

You are not truly prepared to shoot a wedding until you have prepared yourself for photographic competition. At most affairs, you will have family and friends of the bridal couple shooting alongside of you. These amateur photographers are aware that you know your business and want to capture with their cameras the poses you arrange.

You should make it clear to the bride, before the wedding day, that you do not want others shooting "over your shoulder" because it could affect the quality of your work as well as your operating speed and efficiency. Such a warning should help keep such a nuisance to a minimum. But, whatever happens, conduct yourself in a truly professional manner. Don't panic or argue. Even with such difficulties—and they will occur from time to time—you should be able to do your job as planned.

If you have 10 amateurs shooting over your shoulder, the chances of any of their images resembling any of yours would be slight. Not only are you the pro, but you also have been given the mandate to control the operation. Therefore, don't take intruding "happy snappers" too seriously.

However, even though you should not *hinder* insistent shutterbugs from taking their shots, you should not go out of your way to *help* them, either. Allowing time for five, six or 10 people to take their shots while you wait will cost you more time than you can afford—especially when you're shooting at the church.

Ensuring Correct Exposure—Allowing others to fire flashes while you're shooting could lead to overexposure of some of your shots. That's because one or more unwanted flashes may register on your film, in addition to the flash from your own lights that you had calculated for correct exposure.

Your photos may also suffer underexposure. This would result from someone else's flash triggering your slave flashes just before you shoot. If the slaved units have not had time to recycle, they will not fire when you make your exposure.

If you find it totally beyond your power to prevent others from shooting, you still have two alternatives. Either use remotely controlled slaved lights, that won't be affected by other flashes, or ask the bridal couple to intervene in your behalf. Whatever you do, don't get into a confrontation with any guest or family member.

COMMONLY REQUIRED WEDDING PHOTOS

In the chapters that follow, we offer check lists of commonly made shots. You can use these as a guide and reminder. However, we are not suggesting that you must do each and every listed shot for each and every wedding. It is just a guide.

Some weddings will require that you take more shots than appear on our list, some will require fewer. The extent of your photo coverage will be determined by the size of the initial bridal package selected, the number of people attending, the amount of time afforded you for taking pictures, the cooperation of the principals involved, the nature of the locations, and so on.

Notwithstanding, there are certain shots that we consider "musts." You cannot do a successful wedding, to a bride's full satisfaction, unless such shots have been taken and are available for selection. We shall point out these shots to you as we go along.

Our list contains over 130 different shots that you could take during the course of one wedding. It is advisable to take at least two shots of each situation. That's as a safeguard against such mishaps as a flash not firing or someone blinking at the time of exposure. Making so many exposures takes time—time which you generally will not have. Therefore, you must learn to be somewhat selective with the shots you take, considering the time available to you. You must also learn to work fast.

Quality Beats Quantity—To make your formal shots at the altar, you'll usually be afforded anywhere from 15 to 60 minutes of shooting time. Obviously, the less time you have, the faster you must work. Here's some good, basic advice: When in doubt, shoot fewer shots, of good quality, rather than more shots that are of inferior quality.

At the time a wedding is booked,

discuss the time you'll require to do your photography. Make the bride understand that you want to do as much for her as possible but you'll need her co-operation and a certain amount of time to accomplish it. Good wedding photography does not just happen—it must be created.

Even though you have been afforded a certain amount of shooting time, say at the altar, you can't always depend on actually getting it. During the event, circumstances can change and cause your time to be cut, sometimes drastically. Here, again, is where your professionalism comes in: You must be prepared to handle a change of plans and schedules graciously, work around and in spite of the imposed limitation—and produce fine photographs!

When you are on a tight schedule you'll have to make a value judgment as to which shots you are and are not going to do. Some shots you may be able to capture later on in the evening.

Others may have to be taken at the time they arise or be forever lost.

ORDINARY TOOLS FOR EXTRAORDINARY RESULTS

There are no real "secrets" to wedding photography. The "tools" for success are very basic: A sound knowledge of your craft, good and appropriate equipment, hard work, and sound preparation. A little talent doesn't hurt, either.

Although a camera may be your most essential piece of equipment, it's important to remember that *cameras* do not take pictures—*people* do. To prepare yourself to become a first-class wedding photographer, attend every seminar you can. Read as much about the subject as you can. Go out and practice, practice, practice.

Everyone can take pictures, but few have the talent and skill to capture the emotions of a bridal couple and the atmosphere of their special day.

As a photographer, you're not selling a stereotypical product—you're selling your creativity, If you're a good photographer, your product is unique.

To be a good wedding photographer, you must show a varied mix of qualities: You must be sensitive and yet strong and assertive. You must take charge. Know the shots you want to take, demonstrate the poses you want, then shoot with confidence and speed. Don't wait for a couple to pose themselves, and don't just shoot candids. You must take control, without becoming overbearing.

Wedding photography is a great business that can afford you recognition, reputation and financial security. It can lead you into developing other areas of your photographic skills with ease and success. Be proud of what you do and constantly strive to become better. With this in mind, let's move on to the more technical aspects of a wedding.

2

Equipment, Lighting And Lighting Technique

Owning a lot of excellent equipment does not guarantee fine photographic results. However, to do work of professional quality and also guard against possible equipment failure, there is a minimum amount of equipment you must take to any wedding. And whatever equipment you do take you must know thoroughly. A wedding is no place to test equipment or learn how to use it.

Types of Wedding Photography

All weddings involve two distinctly different areas of photography: Formal and candid. Both encompass photography of individuals, couples and groups.

The formal photographs are planned and posed. All should be well executed and can be done at one or more of the following places and times:

1. In the studio or bride's home prior to the wedding day.
2. On the wedding day in the bride's home or at the church before the ceremony starts.
3. At the church altar immediately after the ceremony.
4. At the reception.

Candid photographs are just the opposite of formal ones. They are "grab" images made on the spur of the moment and generally illuminated with nothing more than a single flash unit on the camera. They are taken throughout the wedding day and during all of its phases with one exception: Candid photographs are not executed during a studio session.

Types of Equipment

Both formal and candid photography require the use of specific pieces of equipment. Some equipment will be suitable or easily adaptable for both tasks, some will not.

We have divided the equipment needed for a wedding into two major categories—portable and studio.

PORTABLE EQUIPMENT

Equipment designed primarily for portability is generally light in weight, compact, easy to maneuver and easy to set up or break down. For example, a typical portable flash unit is self-contained, comprising a lamp, housing and power source.

STUDIO EQUIPMENT

Equipment designed primarily for stationary use, such as in a studio, is usually heavier, bulkier, less maneuverable and more complex to set up and break down than portable equipment.

If necessary, all phases of a wedding can be photographed with portable equipment but not with studio equipment. Many studio pieces will be too awkward, too large or too time-consuming to employ.

Where time and space permit, and the assignment warrants it, you should employ studio equipment and lighting during some phases of a wedding. Such lighting will give the subjects a different photographic appearance from that produced by portable lighting. We shall discuss the use of this equipment in later chapters.

EQUIPMENT DEPENDABILITY

You will be given only one chance to photograph most of the wedding scenes. If you lack a piece of equipment or if something breaks and you have no backup equipment, some opportunities will be lost forever.

For most weddings, you should take two complete cameras, two lenses and two portable flash units. One of the flash units should be a slave (remote-control) unit and your lenses should be different—for example, one of standard focal length and the other a wide-angle lens. If possible, you should take duplicates of all other pieces of equipment.

If you are in doubt as to what equipment to take, take more than necessary, to be on the safe side. The advantages far outweigh the inconveniences.

Cameras, Accessories and Film

There is no single way to photograph a wedding properly. All experienced wedding photographers have learned special methods or tricks that seem virtually endless. As a first step, we offer here some suggestions about camera equipment.

CAMERAS

Weddings are really the province of the small and medium format cameras: the 35mm and the 2-1/4-inch formats.

Many successful photographers record weddings with 35mm equipment. It is light, compact and easy to use. With today's fine optics, there is no problem in making enlargements. However, we prefer to use the 2-1/4-inch format for weddings for two reasons:

1. You cannot successfully retouch 35mm negative film because it is too small. All retouching must be done on the final prints.

2. Most 35mm cameras will not synchronize with flash at all shutter speeds. This limits your flexibility somewhat when taking certain flash/ambient light shots.

LENSES

Although you can do an entire wedding with the use of only a standard-focal-length and a wide-angle lens, the more optical variety you have and use, the more varied will be the resulting images.

A wide-angle lens—35mm for a 35mm camera or 60mm for a 2-1/4-inch camera—is perfect for interior and exterior views of a church, the reception hall and for groups of four or more people. It's an excellent choice when doing group scenes at the altar and sometimes the only choice when photographing a wedding or reception in a confined area—for example, on a yacht, in a small restaurant or in an apartment.

However, when photographing people with such a lens, aim the camera horizontally, do not get too close to the subjects and don't place people near the edge of the frame. Otherwise, faces and bodies may appear distorted.

The standard lens—50mm for a 35mm camera or 80mm for a 2-1/4-inch model—is an excellent lens to use when you wish in-camera cropping. It will permit you to get a closer, more intimate image of your subjects. Because of its limited angle of view, compared with the wide-angle lens, unwanted details will be omitted from the photograph. For example, the standard lens is ideal for capturing couples dancing at a reception or for more intimate views of the bridal couple at the cake table.

A medium telephoto lens, also called a portrait lens—100mm for a 35mm camera and 150mm for the 2-1/4-inch format—is a perfect lens for portrait photography. Because this lens tends to compress and blur the background, its primary application is for intimate views—tight head-and-shoulder shots of the bridal couple, individually or together, and tight head-and-shoulder shots of family members at the reception.

Another excellent time to use this lens is during the ceremony. Position yourself at the rear of the church and use the portrait lens to take some photographs of the bridal couple while they are standing or kneeling at the altar. Using only available light will enhance the natural appearance of the scene and produce very attractive prints. After making a few exposures with the portrait lens, switch over to the standard lens for a more expansive view of the proceedings.

FILTERS

Used with discretion, several filters can help to add something extra to your wedding photographs.

Diffusion Filter—A soft-focus or diffusion filter is useful for wedding photography. However, like any other filter, don't overuse it or its impact will be lost. Use a soft-focus filter particularly during the romantic phases of a wedding. It will help to give your photographs of the bridal couple an ethereal or dream-like look. Beware of using too strong a diffusion filter, or the resulting images may appear out of focus to some people.

Warming Filter—Add some "snap" and sparkle to outdoor photographs executed on dull, overcast days, by using a warming filter on the lens. A filter equivalent to an 81A light-balancing filter is generally ideal. Your subjects will like the results.

Starburst Filter—When you are taking available-light shots from the rear of the church, the use of a four-point starburst filter can add an ethereal look to your images. The scene must contain point light sources, such as candles. If you use flash, be careful not to overpower

those light sources with the flash, or the effect will be destroyed. Balance the flash for correct exposure of the subjects and underexposure of the background.

Other Filters—There are many other special-effect filters. They include multiple-image filters, two- or three-tone filters and split-image filter. All of them have very limited application in wedding photography.

Filter Quality—Whatever filters you plan to use, make sure you buy filters from reputable manufacturers. It makes no sense to spend hundreds of dollars for a lens and then use a cheap filter that degrades the images.

EXPOSURE METER

Throughout the various phases of a wedding, you will often be photographing by ambient, or available, light. At other times, you'll photograph with flash as the main light source or by ambient light, using flash as a fill light to lighten shadows. You can combine flash and ambient light in different proportions to get different lighting effects.

For correct exposure evaluation, it's essential to have a good light meter, capable of making accurate readings, even in low light levels. We use the Minolta Auto 3F meter, usually in the incident-light mode.

Before a ceremony starts, we take an incident-light reading from the spot where the couple will stand of the ambient light reaching that area. The dome of the meter is aimed toward the rear of the church.

You must be sure to ask the church officials if they intend to raise or lower the light level for the actual ceremony. You don't want to be caught by having metered the wrong light condition.

We like to overexpose by one full *f*-stop from the exposure indicated by the meter reading. That's because we use color negative film, which should be adequately exposed to ensure full detail in shadow areas. With color slide film, you would generally tend to give a little less exposure than indicated by the meter to ensure good color saturation.

TRIPOD

A tripod is uncalled for in the shooting of most wedding photographs. However, when you do need one—for the formal portraits and some of the shots made in the church—be sure you have a strong, sturdy model.

Most tripods have two handles, one controlling the pan and the other the tilt of the camera. We use tripods with ball-and-socket heads that enable us to direct the camera in any desired direction with one simple movement.

We like to use sturdy tripods on location and somewhat heavier, sturdier, but easily maneuverable camera stands in the studio.

FILM

There is a great selection of film to choose from. Before you make a selection, you have to make some basic decisions. First, what film size do you need? It depends on the camera you use. Do you want to shoot black-and-white or color? Nearly always it will be color. If color is your choice, do you want color slides, or negatives from which enlargements can be made? Most professional wedding photographers shoot color negative film, from which enlargements can easily be made. What lighting conditions are you going to shoot in? This determines the film speed you need. Finally, you have a choice—although a more limited one—regarding which manufacturer's product you prefer.

It's advisable to do some experimenting to determine what film serves your particular purposes and tastes best. Then, get used to the one you like best, and don't change unless you have a good reason. You'll get more consistently good results if you work with one film you're really familiar with than by skipping from film to film.

Finally, be sure to always have plenty of film with you at a wedding. Running out during this important event, which cannot possibly be reshot at a later time, is totally unthinkable.

Lighting Equipment

To photograph a wedding well, you'll need some artificial illumination. That illumination will almost always be electronic flash.

STUDIO FLASH

Professional studio flash heads are generally separate from their power source. Such units are more expensive, heavier, and more cumbersome to set up and use than portable flash units. However, their power output and versatility far exceed those of portable flash units. A studio flash is neither better nor worse than a portable one, just different. Each has its own area of application.

All wedding photographers have their personal preferences for types and brands of equipment for certain jobs and we are no different. In the studio flash category we use Balcar and Norman lampheads and power packs. Our power packs range from 250 watt-seconds to 5,000 watt-seconds. This great versatility in lighting power allows us to use lights at greatly varying distances and with a wide range of *f*-stop settings.

Each time you double the power output of a flash, one whole *f*-stop is gained. If you were to position a subject 10 feet away from a flash connected to a 500-watt-second power pack, and a meter reading of the light falling on the subject indicated an *f*-stop of *f*-16, increasing the power to 1,000 watt-seconds would produce a reading of *f*-22.

PORTABLE FLASH

Portable flash units have less power capability than their big brother, the studio flash. Most portable units yield 200 watt-seconds of power or less.

Like life itself, photography involves a series of compromises and the choice of a flash unit involves one of them. By selecting a portable flash over a studio unit you will gain certain advantages and lose others. For example, portable units are light, compact and easy to set up but offer limited power range.

In the portable flash category, we like the Vivitar Model 283. It's the workhorse of our wedding industry. There may be other units on the market that function just as well, but we haven't found one whose performance compares with that of the Model 283.

Although the Model 283 can be used in manual mode or any one of four automatic modes, we almost always use ours on automatic. This eliminates the necessity of juggling f-stops, distances and guide numbers when doing a fast-paced wedding.

Modifying the Portable Flash—
Portable flash units are mainly designed to be powered by replaceable or rechargeable batteries. Standard batteries are acceptable for intermittent, short-term photography. However, when doing a long photography session such as a wedding, you need something more durable. We use gel-cel rechargeable batteries, costing about $50 each. Although they are small, they recycle the flash faster than any other units we have found and last about one year. One charge will last through an average wedding. To use this type of battery in a portable flash, the flash unit has to be modified. To learn whether your flash can be so adapted, contact Armato's Photo Services, 87-29 Myrtle Ave., Glendale, NY 11385, telephone (718)-441-6888.

USING PORTABLE FLASH

When photographing a wedding, you should concentrate on poses, expressions and actions without being overburdened by mechanical or technical aspects of photography. This is one of the reasons we set our portable flash units on automatic for most of each wedding. We want to keep the operation simple.

By adjusting the flash to automatically produce f-11 light and setting the camera's f-stop to f-8, we add one extra f-stop of density to the film, yielding good printable negatives.

Unless we note otherwise, all of our wedding candid photographs in this book were shot at one of two settings: Flash on automatic to emit f-11 light, camera at f-8; or flash on automatic to emit f-5.6 light, camera at f-4. The shutter speed in each case is 1/60th second. What could be easier?

Slaves for Portable Flash Units—
Slaves are triggering devices that use "electric eyes" to set off remote flash units without any wire connections to the camera. Their main function is to provide dimensional lighting.

An on-camera flash will yield flat, shadowless lighting on a subject. By moving that flash off the camera and to the right or left of it will add shadows to the subject, giving the appearance of modeling or dimension.

In the studio it is easy enough to think of having two light sources, the main light and a fill light. However, on location a photographer can forget that similar light is possible from portable equipment. The flash on the camera can be the fill light and a remote flash, triggered by a slave, can be the main light.

During a wedding things can happen fast and you may not have the time or space for arranging such "dimensional" lighting. However, whenever you have the opportunity to arrange it, do so. The quality of the image will be much enhanced.

The slaves we favor are the Vivitar SL2 and the Hawk remote-controlled units by Tekno/Balcar. The SL2 is relatively inexpensive, costing between $30 and $40. It's a simple, efficient and reliable unit, especially useful for weddings because it's fast and easy to set up and break down.

There is a problem with any "electric eye" slave. To work, it must "see" the flash from another source. This other source is generally your on-camera flash. But since this slaved light is not directly connected to your camera, any flash will trigger it. If someone in the wedding crowd happens to take a picture before you are ready to, your slaved lights will fire and you'll have to wait until your units have repowered before you can shoot. If you don't wait, you'll risk underexposure of your film because the units will not have reached their full power.

In addition, since the slaves are dependent upon seeing a source flash, you cannot hide them. The source flash must be in line-of-sight with the slaved units. If you position a bridal couple to one side of a pillar and you conceal a slaved light behind the pillar to act as the main light source, the slaved light may not be able to "see" the flash from your camera and may not fire.

The Hawk, by Tekno-Balcar, solves this problem because it is not dependent upon "seeing" anything. It depends upon sound. Thus your slaved flash units will not fire except when you take your photographs. You will need only one sound transmitter but you will need one sound receiver for each light you intend to slave.

You can put sound-activated units almost anywhere, even around a corner and up to about 100 feet from the transmitter. This makes them ideal for creative wedding photography. However, they are expensive. You'll

pay several hundred dollars for this luxury. There are other brands on the market that are far less expensive than the Hawk, but we find them to be less reliable, too.

FLASH REFLECTORS AND HOUSINGS

When a reflector or housing is placed on a flash head, the light is modified, generally by reflection or diffusion. Such light modifiers include metal bowl reflectors, umbrella reflectors and soft boxes or light banks.

Light modifiers can be of many different sizes, shapes, colors, fabrics and surfaces. Each has its special application. Each will affect the final image.

The reflector or housing determines the effective size of the light source. Small light sources, such as a typical portable flash, yield hard light, with sharp and distinct shadows. Large sources, such as a flash reflected from a large umbrella, give softer light, with more gently graduated shadows.

Since wedding photography mainly involves pictures of people and people look well in soft light, it would be ideal to photograph an entire wedding with a large, soft light source. However, it isn't really practical. No one could walk around with an 8-foot soft box to photograph all aspects of a wedding. The use of such equipment has to be restricted to the studio and more formal scenes, where time and space permit.

A matte white reflecting surface will produce a light that's somewhat softer than a silvered surface.

For the formal photos at a wedding, when space and time permit, we like to use one white four-foot soft box for head-and-shoulder or full-length photos of individuals or couples. When photographing a group, such as at the altar, we like to use two six-foot, silver-lined umbrellas. These will produce more light than the soft boxes, yielding a higher *f*-stop setting for greater depth of field.

REFLECTOR CARDS

During a wedding, you may not have the time or space to set up a separate light to act as a fill light. In such cases you can use a reflector card or sheet.

Reflectors of many sizes, shapes and surfaces can be used. When shooting with color film, reflectors should always be white, or of a neutral color such as silver. Otherwise, the reflector would cause an unwanted color cast on the subject. One exception is a gold reflector: It can be useful for filling shadows in open shade, giving the shadow area a warmer glow than would occur with a white or silvered reflector.

A reflector should normally be as large as, or larger than, the subject you're photographing. If you are shooting a head photograph, a small 2x2-foot or 2x3-foot reflector will suffice. If you are doing full-length photographs, a 4x6-foot reflector would be more appropriate. The surface of the reflector will affect the quantity and quality of light reflected from it. A white surface will produce a softer light than one that is silvered. The silvered reflector will also be more efficient, throwing back to the subject more of the incident light than will the white reflector.

Make Your Own Card Reflectors—Although there are a lot of ready-made reflectors on the market, we usually make our own. We purchase 4x8-foot sheets of white foam board from a local hardware store, cut them into 2x4-foot sections and tape four of these sections together to make a 4x8-foot collapsible reflector. We tape crumpled aluminum foil on one side and leave the other side white. This gives two surface choices plus the ability to adjust the reflector's size to the shooting situation.

LIGHT STANDS

For wedding photography, you need light stands that are fast and easy to use, light in weight, but sturdy enough to support either portable or studio lighting equipment. You will also need a stand capable of extending up to eight feet in height while holding such equipment securely.

Churches and temples often have raised altars. A four or five foot rise is not uncommon. For these situations you need a stand that can hold the flash in line and level with the body of the subject. This means extending the flash from six to eight feet from the floor. The Norman LS224 light stand is ideal for this purpose.

Light and Lighting Technique

There is no single way to light a subject correctly, although there may be a lot of wrong ways. As for equipment, it's how you use what you have and not what you have that's really important.

The one light that's essential in almost all photographic situations is a main light. Use it, and any other light—including fill light, rim light and background light—thoughtfully. When you place a light somewhere, you should have a good reason for it.

Learning how to see and use light is a basic requirement for any good photographer. Experiment with all of your lights and housings—but not while you're actually shooting a wedding, of course. Learn how each light and light position affects the appearance of your subject. Employ the light combination you feel correct for the job at hand. Others photographers may not use your mix of lighting, but this fact alone will not make it wrong—just different.

THE FIVE LIGHTING CHOICES FOR WEDDINGS

At any wedding, you will be con-

fronted with a variety of lighting problems. You will not have much time to solve them, nor are you likely to have all the equipment needed for perfection.

For example, at an evening reception, the bridal couple may request a group shot of 40 or 50 people. If you had an hour or so, six 5,000-watt-second power packs, six or so 6-foot umbrellas, and a couple of assistants, you could probably handle the situation with ease. But you'll not have this luxury. Instead, you may have two portable flash units, no assistants and about three minutes in which to execute the shot. Such are the typical pressures of wedding photography.

To handle such problems, we think it's necessary to plan lighting alternatives. Not only is this good preparation, but it also permits you to offer your subjects pictorial variety. For simplicity, we suggest the following five lighting methods:

Available Light Only—The light will come only from available or ambient light. The light will be from the sun, household lamps, other already-existing sources, or even candles, but no flash will be used.

When you are faced with having to photograph solely by ambient light, make sure you meter at the subject's position, with an incident, ambient light meter. Make certain that all subjects are lit evenly. You don't want one person in the scene receiving more light than another.

Portable Flash Only—Most of your wedding photography falls into this category and it's the easiest one under which to work. If you set a portable flash unit on automatic to emit f-11 light and adjust your camera to f-8, or set your flash to emit f-5.6 light and adjust your camera to f-4, you can photograph an entire wedding without ever deviating from those two combinations.

Of course, the recommended overexposure implied by these settings applies only if you're using negative film. With color slide film you should, if anything, reduce the metered exposure slightly, to ensure good color saturation in your images.

Flash and Ambient Light as Main Light—Exposure by flash and ambient light are balanced to give the desired amount of light on the subject. Take an ambient light reading at your subject's position, with an incident meter. Let's assume it indicated f-8 at 1/125th second.

Because we use color negative film, which we want to overexpose, we would adjust our flash to emit f-11 light at the subject position. We would also set our camera to f-8 and the shutter speed control to 1/60th second. The flash will then overexpose the film by one stop because of the f-stop setting and the ambient light will overexpose the film by one stop because of the shutter speed, for a total of two f-stops of overexposure. This may seem like a lot of overexposure but we have found, from practical experience, that it yields excellent prints.

Flash Main Light and Ambient Fill Light—The subject lit by the flash will be exposed according to the f-stop setting used. Everything in the background will be underexposed unless the exposure is such as to allow the ambient light to record on the film.

Here's an example: Take an incident meter reading at the subject's position. Assume that the meter indicates f-8 at 1/60th second. When shooting color negative film, set your flash to emit one more f-stop of light than the meter indicated, in this case f-11. Set your camera to f-8 and 1/60th second. This setting will allow the flash to overexpose the film by one full stop—exactly what you want for good density on your film.

The ambient light will be exposed correctly according to the meter, but underexposed by one f-stop according to the camera settings. This is quite acceptable under the circumstances, giving main emphasis to the correctly exposed subjects in the foreground.

Had you wanted more drama in the scene, and if the X-sync setting of your camera permitted it, you could have set your shutter speed control to 1/125th second. The ambient light would now yield two full f-stops of underexposure.

Ambient Main Light and Flash Fill Light—This method is useful when your subjects are lit by the sun from the side, so that distinct and deep shadows are caused. Begin by metering the ambient light at the subject position with an incident meter. Assume that the meter indicated f-8 at 1/125th second. To get the overexposure of color negative film that we recommend, set your camera at f-8 at 1/60th second.

Next, set up your flash, on or near the camera, and adjust it to emit f-5.6 light. Since f-5.6 light is less powerful than f-8 light by one full stop and since your camera is set at f-8, the light from the flash will result in underexposure. Your flash has now become a fill light source. The shadows will be lightened but not eliminated altogether.

Synchronization and Flash—A camera such as a Hasselblad, that has a leaf shutter, will synchronize with electronic flash at any shutter speed. The focal-plane shutters in 35mm SLR cameras, on the other hand, impose some limitations. Some will synchronize only up to 1/60th or 1/125 second. Each camera's manual will inform you what the camera's limitations are.

As long as film is exposed at the recommended sync speed or slower, shutter speed does not affect flash exposure. Whether light from a flash unit exposes your film sufficiently depends solely on the f-stop setting. Shutter speed controls only the

amount of ambient or available light reaching the film.

Therefore, if you are photographing an evening wedding with flash and are not concerned with introducing any of the ambient light into your scene, you can set your camera at 1/60th second and leave it there for the entire wedding, exposing all of your film solely by flash illumination.

Bounce Flash—Wedding photographers frequently use their portable flash units in the bounce-flash mode. Instead of pointing the light directly at a subject, they bounce it off a wall or some other surface first. The wall or other surface effectively becomes the light source, now much larger than the on-camera flash head itself. This produces softer light.

We rarely employ the bounce method. Because most portable flash units have no modeling lights, you have to guess where the bounced light is going to strike a subject. You must also be careful to bounce only from white surfaces. Otherwise, your subjects would take on an unwanted color cast of the same color as the reflecting surface.

Another problem is considerable light loss through scattering from the reflecting surface and the greater distance the light has to travel. With some flash units, this can present some exposure problems.

If your purpose in using bounce light is to obtain soft light, use a soft box with direct light instead. This will eliminate any guess work.

Our Wedding Equipment List

Almost all wedding photographers offer a choice of various photo-album combinations for package prices. For a modest price, they offer a limited quantity of prints of a certain size or combination of sizes in an inexpensive album. For a higher price, the quantity of prints and sizes increase, as does the quality of the album. Among professionals these packages are referred to as *bridal packages.*

The price of the bridal package has a great bearing upon the quantity and type of equipment a photographer takes to a wedding. For an inexpensive bridal package, less shooting and less equipment will be needed. The more expensive the bridal package, the more time you will spend and the more sophisticated the poses, the lighting, and the equipment you'll use.

When deciding how much equipment to take to photograph a wedding, you should also consider the size of the wedding party and family group to be photographed, the length of time to be spent at the affair, the attractiveness of the wedding location and how elaborate or involved the event is to be.

A sunrise wedding on a beach, in-

volving only a bride and groom, best man, maid of honor, a few guests, a simple setting and one hour of your time will require minimal equipment. A wedding that is to last eight hours, cost thousands of dollars, have 18 people in the bridal party as well as 200 guests and dozens of family members to photograph, and several gorgeous locales, will almost certainly require extensive equipment.

Because of these variables, we offer you a list of equipment we would use for an average wedding consisting of a bridal party of approximately 10 people and lasting about five hours. This choice of equipment also assumes a bride's selecting our medium-priced bridal package. All of the equipment would be portable.

1. Two camera bodies.
2. Three lenses: wide-angle, standard and medium telephoto.
3. Soft-focus filters.
4. One warming light-balancing filter.
5. Four-point starburst filter.
6. Two exposure meters.
7. Fix-it kit: all the items mentioned in Chapter 1.
8. Three portable flash units.
9. Two wide-angle dispersers for the flash units.
10. Three rechargeable gel-cel batteries.
11. Two remote-controlled, ultra-sound slave unit receivers and one transmitter.
12. Two slaves for the electronic flashes.
13. Four synchronization cords.
14. A roll of black tape and a roll of gaffer's tape.
15. One kit of small jeweler's screwdrivers.
16. Kodak color negative film.
17. One tripod.
18. One package of plastic sheeting, to cover wet ground.
19. Cable releases.
20. One two-step metal stepladder.
21. Small flashlight.
22. Lens cleaner and tissue.
23. One collapsible, silver/white reflector.
24. Small plastic bags to cover the cameras in case of rain.
25. Two lightweight light stands.

For that special wedding affair, where the bride has selected a substantial bridal package, where time is not a factor and the subjects want photographs that have a "special" look, we would add this studio equipment:

26. Two four-foot soft boxes.
27. Two heavy-duty light stands.
28. Two 1,000-watt-second electronic flash power packs.
29. Three flash heads.
30. Two synchronization cords.
31. One Minolta flash meter.
32. One portable 6x6-foot, earth-tone background.
33. One background light.
34. One posing stool.
35. One hundred feet of extension cord.

= purchase

= have

3

Formal And Casual Portraits

A photographer should offer formal photography, generally taken before the ceremony, and casual or candid photography, taken throughout the wedding festivities. A formal studio or location session will yield prints that have a different look from wedding candids. The combination will provide a wide variety of images.

At the wedding itself, you must shoot in the surroundings the *bride* has chosen. Formal photography gives *you* the choice of location.

Formal Portraits of the Bride

Among professionals, a formal photography session of the bride is termed a *pre-bridal session* because it is generally done before the day of the wedding. It requires at least two hours to execute correctly—a length of time not generally available on the actual wedding day.

The pre-bridal session serves to produce a series of photographs of the bride-to-be in her wedding gown. The session includes tight head shots

and head-and-shoulder images, as well as three-quarter-length and full-length photos. For best control of lighting and background, we shoot most of our formal photography in our studio. However, we also shoot at other places, such as the bride's home or an outdoor location.

There are wedding photographers who don't do bridal sessions. We think they're wrong. If you are going to photograph weddings as a business, then you should be a full-service photographer and offer whatever photography is required or associated with the wedding. In our opinion, the pre-bridal session is an important part of wedding photography.

The reason that you are photographing someone's wedding in the first place is to preserve the emotions and events of the day, and that includes the loveliness of the bride in her gown. You will want to include not just quick candid views, but also carefully planned, posed, competently executed photographs, to do full justice to the bride's face and the details of her gown.

PAY ATTENTION TO DETAIL

During a formal session, you must pay strict attention to details such as the fluffing of the bride's gown and train, the placement of the veil, and the bride's makeup and hair. You may have to adjust her hair, add makeup or even play seamstress and tack the dress where it doesn't fit correctly or pin the skirt or veil to the floor so that it lies properly. Not only will this attention yield a more professional look to the photographs, but the bride will appreciate the extra time and effort you expend. You'll make her feel special.

During the wedding ceremony and in other candid photography phases, you may not have the opportunity to pay attention to such details, but during a formal photography session, where you have an abundance of time and little pressure, there is no excuse for not being attentive.

POSES

Whenever you photograph a bride in a formal session you should place her in various poses to cover all

aspects of the gown and her face. We normally follow a routine that starts with full-length shots:

1. The back of the bride's dress and train, with her face in profile.
2. The front of the gown, with the bride facing the camera.
3. Each side of the dress, with the bride in a three-quarter position.

After the full-length photographs, we do a series of seated poses with the aid of a Victorian chair or attractive bench. These photographs will primarily be three-quarter-length. First, the bride is seated so that her back is partly facing the camera, with her face in profile. Then, a frontal shot is made, and finally a three-quarter view from each side.

A series of head images follows, including full-face, three-quarter and profile. If your subject doesn't have the facial structure to support a good profile image, make the photograph anyway. You'll be amazed at how often photographs you think are less than superior will be well received and will sell.

Whether it be a full-length, three-quarter or tight head view, once the basic pose has been established take several photographs to capture various expressions. Then, modify the pose slightly and make more exposures, before making a major change. Also change your lighting from time to time, to afford extra pictorial variety.

BRIDE'S ASSISTANT

Whether you are doing a formal session in your studio, the bride's home or elsewhere on location, it will not be uncommon for the bride to have someone with her at the session. She may bring a girlfriend, her maid of honor, her mother or some other relative. The bride will have brought this person to assist her with her gown, her hair and her makeup or just for moral support.

You should encourage the helper to

sit in on the session and so be able to report later to the bride how wonderful she looked while being photographed.

In addition, no matter how much contact you may have had with the bride prior to the formal session, compared with the helper she has brought with her you are a stranger. After the bride and helper have left you, if you have done your work well the helper will praise you and your work to the bride. This will reassure the bride that she has made the proper choice of wedding photographer, and it will make your job easier at the wedding.

WHOM ELSE TO PHOTOGRAPH?

Most of the pre-bridal session photographs will be of the bride alone, but often the bride will want other people included with her. Her mother, a sister, a child from a previous marriage, or even her husband-to-be are all likely candidates. You should encourage these additions. The resulting photographs are bound to be in demand.

When the session is to include other people, be certain to do a series of photographs of each individual alone as well as with the bride. This affords variety and choice to a bride and to the other participants and an opportunity for you to increase your sales.

EQUIPMENT AND LIGHTING

For an outdoor formal session, use portable lighting equipment. The flash on your camera can act as a fill light and a second, off-camera flash on a stand can act as the main light.

For an indoor formal session, studio equipment should be used, if available. Images created with this type of equipment will have a distinctly different appearance from candid shots.

For low key images with a dark

background, use a main light, a fill light or reflector and a back light. If you prefer to have some illumination on the background, an additional background light will be required.

Our basic studio lighting setup for full-length and three-quarter length views consists of a main light in a six-foot, silver-lined umbrella, a four-foot soft box as fill light, and a back light.

For high key work, some additional lights are needed: One on either side of a white background, for even illumination.

For tight head and head-and-shoulder views, a softer source, located closer to the subject, should be used as the main light. We use a four-foot soft box or a bowl reflector covered with diffusion material. A white 3x3-foot reflector board, placed below the face of the subject, out of camera view, serves to bounce some light back into the eyes of the subject and so add sparkle.

LIGHTING THE GOWN

During the entire formal session, it is essential to display the bride's gown to its utmost. This entails paying close attention to lighting—its quality and direction.

To record detail in a white wedding gown, do not light it by direct, flash-on-camera light. The gown should receive oblique light, crossing the gown at an angle rather than striking it straight on.

By using oblique lighting, you will cause light and shadows to dance in and out of the folds of the gown, giving it dimension. The more oblique the lighting—that is, the farther to the right or left of the camera you move the main light—the more dramatic will be the shadows on the gown and the more vibrant the image.

In your studio you can control your lighting and choose the source, power and combination of lights for the effect you want. Outdoors you may

have to compromise. Choose the time of day and weather conditions as best you can.

A cloudless day at noon may produce light that is perfect for the gown but too harsh for the face. An overcast sky early in the morning may yield lighting that is ideal for the face but too soft for the gown.

The best time to do a formal session outdoors is early in the morning or late in the afternoon, when the sun is low. The presence of some clouds— as reflecting surfaces—helps. This will yield a light not only soft enough for a bride's face but also crisp enough to bring forth the details in the gown.

The closer the main light source is to the camera viewpoint, the flatter will be the lighting. Texture and detail of the gown will be greatly lessened because shadows will fade and disappear. This is one of the reasons that candid photographs, lit only by on-camera flash, do not look as dramatic as formally lit photos.

BACKGROUND

For most of our formal studio sessions, we use a black velvet background. Against it, the white bridal gown stands out vividly. We'll also use an all-white or high key background to vary the appearance of the bride and provide an innocent, ethereal look.

At the bride's home or elsewhere on location, a portable background can be used. For head views of individuals or couples, a 6x6-foot background is adequate. When photographing three or more people or doing full-length views, a 9x18-foot background will be required. White or earth-tone seamless background paper works well for this purpose.

If a portable background is not used on location, become very selective about where you position the bride. Keep the area behind her as uncluttered and as simple as possible.

You want nothing to compete with the bride's gown. Flowers, trees, plants, tables, chairs and other objects can be distracting in an image and will de-emphasize the gown. You should either minimize background elements or make them a subtle, supporting part of your scene. This may involve moving one or more of those elements, or the bride.

Casual Photographs of Bride and Groom

Wedding photographers often lose sight of the fact that a wedding involves two main people—the bride and the groom.

Since tradition has the bride or her parents hiring the photographer and paying all the costs attendant to the wedding, one tends to cater to a bride and to give scant attention to the groom. Many images—and sales— are lost as a result.

Many of the brides we photograph do not want their husbands-to-be to see them in their wedding gowns before the day of the wedding. Tradition has schooled them into believing it is bad luck. However, no such problem exists with photographing the couple in casual clothing and in a casual environment.

A casual photo session gives a couple an opportunity to "dress down," to wear their favorite clothing, and engage in relaxed, happy and often romantic poses.

Furthermore, you'll be able to choose the time of day, the lighting, the locale, the background and foreground. This control will result in photographs that will be great additions to the bridal album, and your sales will increase accordingly.

Often, a couple will have no good photographs of themselves, either alone or together. The casual session affords them the opportunity of obtaining some excellent portraits.

The casual session also affords you

the opportunity of becoming better acquainted with the bride. At the time of booking her wedding, your exchange with her was formal and brief. At a pre-bridal session, you'll be able to spend more time with her. You'll have a chance to become friends and not just hired help. This last benefit is the most important of all because it will lead to making your job at the wedding easier. You'll receive more co-operation from all concerned.

The session also affords you the opportunity of building a strong rapport with the groom. This also makes your job easier and smoother when photographing the wedding ceremony.

By doing the session before the wedding day, you will find that any additional time needed is usually no problem. On the wedding day, time will generally be at a premium.

CLOTHING

Prior to the day of the casual photo session, have a lengthy discussion with the couple about the clothing they should wear. They should dress in the same color or at least in the same tone. Their clothing should harmonize as much as possible.

They should also be dressed in a similar style of attire and in keeping with the environment in which they are being photographed. You don't want the bride dressed in a white cocktail gown and the groom dressed in white jeans and sweatshirt.

Instruct the couple to avoid clothing with patterns—checks, stripes, prints or plaids. The resulting images would appear too busy. Your images should emphasize the subjects, their facial expressions and body language, not their clothing, which should be merely a supporting element.

IN THE STUDIO

Most of the casual sessions done in our studio are executed with white

backgrounds, for a high-key effect. Such a background serves well for casual photography because the mood created is one of lightness and cheerfulness. It works well with casual clothing.

Most men don't like to have their pictures taken. They think they look silly or less than masculine when posing for shots. Therefore, before you start a session spend some time with the couple, and especially with the groom. Let them both know what you are going to do and what is involved for them. This will help put the groom at ease, gain his cooperation, and make the session go more smoothly.

If you have done your work well, by the end of the session the groom will be the first one to thank you for your efforts and express regret that the session is concluded. He will have had fun.

ON LOCATION

We prefer location sessions to photography in the studio. The men feel more relaxed and, because of this, the brides become more relaxed, too. Better photographs result.

The location session can be done anywhere where there are beautiful surroundings. Because we happen to live in southern Florida, we take advantage of the beach and do most of our location sessions there, at sunrise.

In any case, whether it be amid falling leaves in Maine or sunsets in California, such casual photography sessions of bridal couples outdoors can yield stunning images that will be great contributions to beautiful wedding albums.

Choose Location Carefully—A location should be chosen because it contains at least one fantastic photographic area: a waterfall, a wooden bridge that spans a brook, a floor of deep green grass, a heavily wooded area where light streams through the trees. Don't choose a location simply because it is convenient.

Few locations are so versatile that they will serve for all the casual sessions you want to do. Therefore, have several on your list and choose the one appropriate to the task at hand.

If you are unfamiliar with all the likely spots in your area, a visit to your local city hall, and particularly to the department of parks and recreation, will help. The people there will be able to advise you.

Whatever you do, don't attempt to find a location on the day of the scheduled session with your subjects. By the time you find the "just right spot" the couple will be exhausted and in no frame of mind to spend an hour or so being photographed. Find the location well in advance of the photography session.

EQUIPMENT AND LIGHTING ON LOCATION

Limited equipment is needed for a casual session on location. We use only one lens—a portrait lens of 100mm for our 35mm cameras or of 150mm if we are using Hasselblad equipment. We prefer the effect the portrait lens gives. With either a standard or wide-angle lens, the background becomes too remote, the sense of space behind and around the couple too much for our taste. With the portrait lens, the background is more compressed and the couple appear more involved with the space around them.

You'll need a tripod and a cable release. Often, you'll be working with very slow shutter speeds and you don't want to risk blurring your images by handholding your camera.

If you are at a beach, the sand will act as a natural reflector. Should you desire to use a more controllable fill light, a simple fold-up 4x8-foot foam board will suffice.

You'll need flash. We use one remote Vivitar 283, mounted on a light stand, connected to a Hawk remote-

controlled receiver.

If you don't want to invest in the Hawk equipment, use two flash units. Attach one to your camera and put the other off-camera and slaved. Set your on-camera flash to emit its least powerful light. Your remote light will be your main light. The flash on your camera will have no effect on the picture except to trigger your off-camera flash. Of course, the slave unit must be such as not to be triggered by the ambient daylight.

Other than camera and film, you'll need no other equipment.

Filtration—Filtration can be important when you do outdoor sessions. When we shoot at the beach, for example, we use a U.V. filter or a weak warming filter. The warming effect on the final prints is desirable even if you have an already colorful day.

On a gray day, or in open shade under a blue sky, such filtration is essential. At sunrise or sunset, a warming filter further enhances the existing warmth of the light conditions.

Exposure at Sunrise—Although we usually start our sunrise sessions well before the sun actually comes up, once it does start to appear we have to work fast. There are only four or five minutes in which to capture the beginning of the new day. During this short span the light changes rapidly, forcing us to meter about every 30 seconds to ensure good exposures.

In our sunrise sessions, we strive to produce photographs that give a deep tone to the sunrise while properly lighting the couple's faces. This means controlling the ambient light by underexposing the film to it, using the camera's shutter-speed control, and illuminating the subjects with flash controlled by the camera's *f*-stop setting.

For example, at the beach we might stand a couple near the water's edge, with their backs to the water and sun. We'll take an incident-light meter

reading of the sky, with the dome of the meter facing the horizon and pointed slightly to the left or right of the sun, and level with the horizon. We will then take an incident-light reading at the subject's faces, with the dome of the meter pointed toward the camera.

Assume the meter indicated a reading of f-8 at 1/8th second for the sky and f-8 at 1/2 second for the subjects. We would then set our camera to f-8 at 1/30th second. At such a setting the faces of the couple would be extremely underexposed and therefore dark. To avoid this we would use one portable, remote-controlled flash on the subject's faces and adjust it to emit f-11 light. With our camera still set at f-8 at 1/30th second, this would overexpose the subject's faces, from the flash, by one full f-stop while underexposing the background by two full f-stops. On color negative film, this would produce a good image of the sunrise while properly exposing the subjects.

We happen to shoot at sunrise because our beaches in eastern Florida happen to face East. The same principles described here would apply when shooting at sunset.

Props—For an outdoor casual session, props required are simple. A picnic basket, a blanket, two wine glasses and a bottle of wine will usually suffice. Keep props simple, to avoid distracting attention from the couple or the surroundings.

POSING

There are no hard and fast rules for poses, as long as they suggest love and togetherness. When photographing, try to keep both people in the same plane of focus. This will enable you to work with one off-camera light, minimize any depth-of-field problems, and move quickly from one pose to another.

The Professional Approach

Most brides tend to be nervous, in formal and casual session alike. They will not know what to expect or what is expected of them. Most will not have been photographed in years. Others may exclaim that they dislike being photographed because they photograph poorly. Whatever excuse or reason they give, you must be prepared to take charge to ensure that the session runs smoothly. To accomplish this we offer the following advice:

USE MUSIC

Whether in a studio or on location, we have found that having some type of background music throughout the session helps relax all subjects.

BE PREPARED

No matter where the formal photography session takes place, have your equipment set up in advance. When the bride is finally dressed and ready to be photographed, she can be escorted to the camera area and the session can begin with minimal delay.

When the session is to take place in an unfamiliar location, visit the area well before the planned shooting time. You'll need to be familiar with possible problems you might encounter photographing in a particular area and you'll need time to think about the solutions.

Preparing for a session—any session—is a must. If you don't prepare, a lot of valuable time will be wasted and your credibility may suffer.

FOLLOW A PLAN

It is most important to have a definite procedure and a set of poses you intend to use, before the bride ever steps before your camera. Don't make her wait until you decide what to do next. She'll lose patience and confidence. Creating poses on the spot is great for extra shots but all your main poses should be thought out in advance.

SHOW CONFIDENCE

No matter where the photography takes place, the bride and all onlookers will be watching you and how you conduct the session. It is most important that you appear to know what you are doing—even if sometimes you don't! If you make a "big deal" about setting up a pose or moving a light at the pre-bridal session, a bride might have second thoughts about entrusting her wedding to you.

You may well be more nervous than the bride—but don't show it!

COMMUNICATE

Whether subjects have been photographed many times before or not, they share one thing in common: None of them will be familiar with what you are trying to accomplish. Demonstrate each pose in advance. Show the subject how to place her body, head and hands. Never assume that she understands. Help her. This, too, makes the session go more smoothly and quickly.

Photos in This Chapter

With the exception of the beach photographs, and unless we indicate otherwise, the following information applies to all of the images presented in this chapter:

The point of focus was the eyes of the subjects. The camera settings were f-11 at 1/60th second. This setting gave 1/2 f-stops overexposure based upon an incident-light reading of the main light.

A Hasselblad camera was used with a 150mm portrait lens. A 1,200-watt-second Balcar power pack and head were used for the main light. The fill light power pack and head were the P-2000 and LH-2000 by Norman. Back lights and kicker lights were by Norman, with Norman P-500 power packs.

The housing for the Norman fill light was a four-foot soft box by Chimera. The housing for the main light was either a 42-inch white umbrella with a shower-cap diffuser or an opal-light bowl reflector with a 20-degree grid spot and an amber pyrex gel with a shower cap diffuser, all by Balcar.

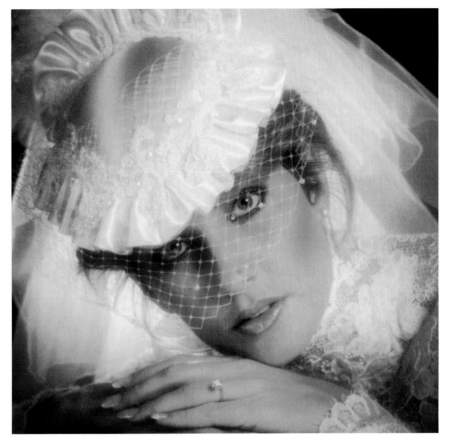

Tight head views, such as this one, are easy to do and are great additions to a bridal album. However, not every subject will have the facial structure that will support such a close-up shot. This subject does. She is posed by a stool covered with black velvet and placed 6 feet from a black velvet background.

The main light was in a 42-inch umbrella at about 40 degrees to the right of the camera. A white reflector was used under the subject's chin to add more sparkle to her eyes. A back light was adjusted to give one f-stop more light than the main source.

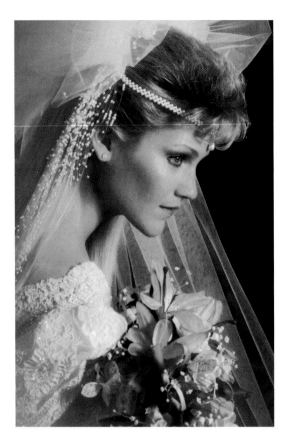

This image is not for everyone. The subject needs a good profile. This subject was seated on her right hip and leaned slightly toward the main light, which was approximately 90 to 100 degrees to the right of the camera. The main light was in a 42-inch umbrella. The fill light was set to emit *f*-8 light. The back light was adjusted to a power setting equal to that of the main light. An amber gel was used on the back light to add warmth to the image.

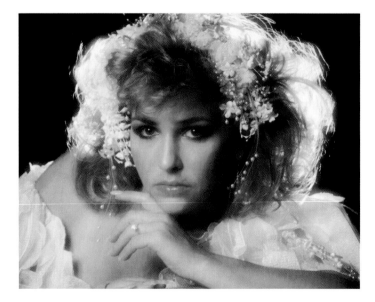

An Opal light was used for this photograph, to give a warm color and enhance the mood. White back light, with a power setting of two *f*-stops more light than the main light, washed out the detail along the outer edges of the hair. This helps to keep the viewer's attention on the face. The main light was to the left of the camera. Only a white reflector was used as a fill for the shadow side of the face.

This is not a traditional bridal head view. However, it enriches a bridal book and increases sales.

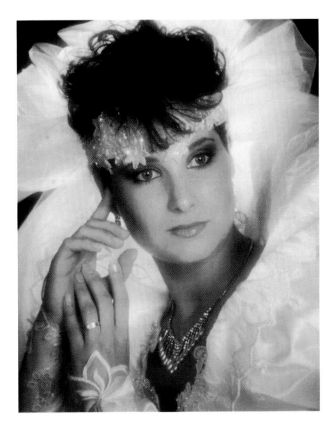

This is a more traditional pose. The main light it was put on the right side of the camera. The overstated back light added to the regal appearance of the bride. Although the main light was pointed toward the subject's nose, the light crossed her body, giving detail to her gown while at the same time emphasizing her face.

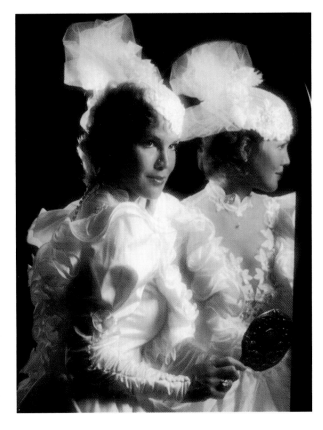

This image shows a different effect in a three-quarter pose. The use of a simple prop like the stand-up mirror allows the viewer to see both the front of the dress and part of the side and back. The main light was placed about 20 degrees to the left of the subject's nose, causing more of her right side to be in shadow, for a dramatic result. The fill light was set to one-fourth the power of the main light. We did not want it to compete with the main light or the light reflected from the mirror.

Take the opportunity to deviate from traditional photographs, as we did in this one, which we made for fun. Such photographs sell. The fill light was intentionally kept at one-fourth the power of the umbrella main light to keep the legs from being too prominent. The main light was placed about 40 degrees to the right of the camera to enhance the detail in the gown. The power of the back light was balanced to equal that of the main light.

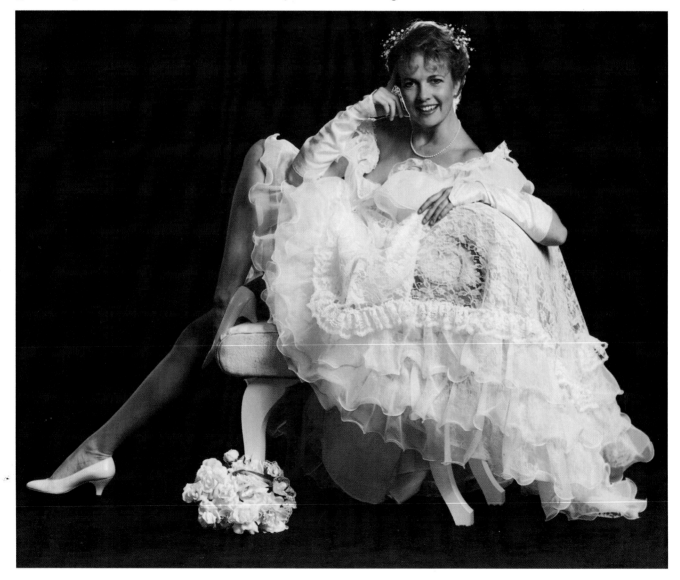

The simple use of a posing bench in this shot served a dual purpose: It gave the bride something to lean upon and it kept a lot of light from falling onto the bride's waist, thereby slimming her small waist even more. The main light was a 42-inch umbrella with a fill light set at half the power of the main light. A back light was adjusted to give one *f*-stop less light than the main light, to outline the veil. The main light was placed about 20 to 30 degrees to the right of the camera. This thinned the subject's face, increasing the dramatic effect.

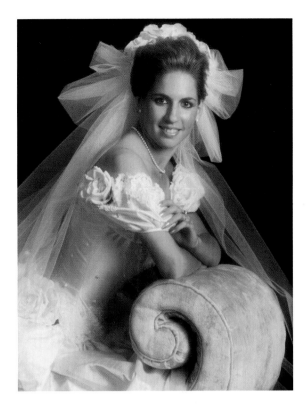

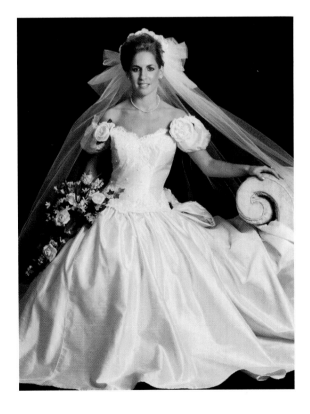

In this pose you will notice that, because the bride's body is turned more directly toward the camera, the waistline is less flattering than in the previous view. The flowers could have been placed more in front of the body rather than to the side but, because of their size, a portion of her dress would have been concealed. Since the main light was placed about 30 degrees to the right of the camera, the light played across the bride's gown, bringing forth detail.

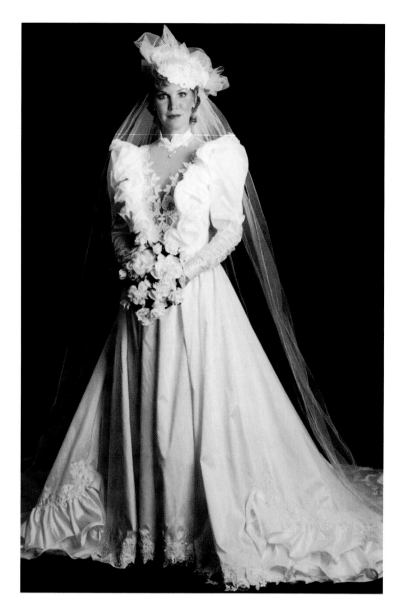

This is a traditional, full-length photograph. A 42-inch umbrella main light was placed about 25 degrees to the right of the camera. With such oblique lighting, detail was brought out in the gown, along with good modeling of the face. The fill light was placed to the left of the camera at about 10 degrees and was set at half the power of the main light.

In such a pose, it is essential to keep the bride's flowers centered and below her bustline. You don't want them obstructing the upper portion of the gown.

Almost all sessions should include a view of the back of the bride's dress. Here, the main light was placed 90 degrees to the right of the camera. The fill light was also to the right of the camera but at about 45 degrees. It was set at half the power of the main light. In addition, a kicker light, used to outline the veil and left side of the gown, was placed to the left of the camera, at about 90 degrees. The kicker light and a back hair light were both set at half the power of the main light.

Almost without exception, no soft focus should be employed for the full-length views. Such filtration reduces detail in a bride's gown.

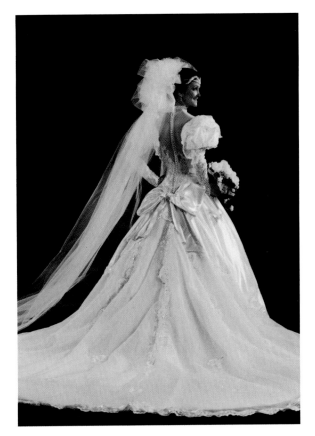

This is a good example of a bride being photographed with a family member. It's a great and popular addition to any bridal album. One opal light was used for this photograph, to the left of the camera. The back light was set to emit one *f*-stop more light than the main light. A fill light was used to the right of the camera, set at one-fourth the power of the main light.

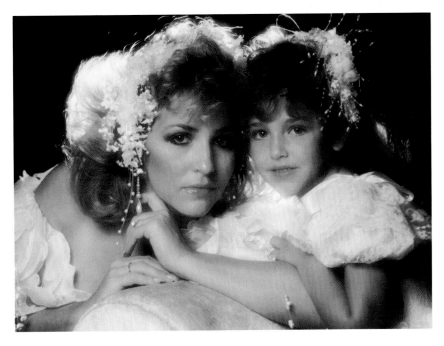

Mother-daughter photographs always sell. This example was no exception. A 42-inch umbrella light was used as the main source and placed close to the camera. The mother was seated, to give the bride prominence and to display the bride's dress better. The fill light was to the left of the camera and was set at half the power of the main light. The back hair light's setting equaled that of the main light.

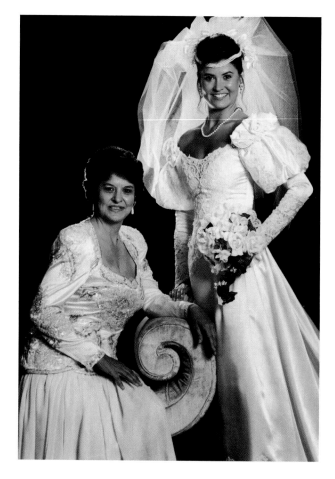

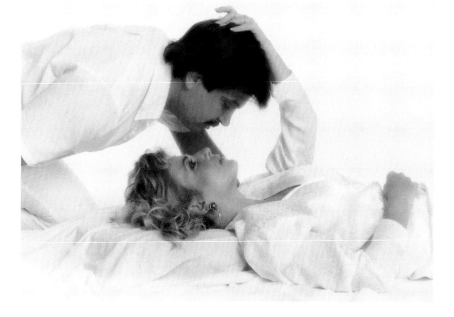

Your subjects don't always have to look at the camera. This image clearly bespeaks love. The white background received two f-stops more light than the subjects received from the main light. The fill light was at half the power of the umbrella main light. The main light was at f-22, while the camera was set at f-16. A warming filter was used.

These were very casual people and poses such as this one worked well with them. Poses should always be in accord with the character of the subjects.

Unless noted otherwise, the following equipment and technique were used in all of the beach photographs displayed in this chapter: a Hasselblad camera, a 150mm portrait lens, an 81A warming filter, a Vivitar 283 flash, remotely controlled by the Hawk by Tekno-Balcar, and a Minolta Auto 3F meter. The Hasselblad camera was set at f-8 and its shutter speed at two stops under what the meter indicated for f-8 light. The flash was set on automatic and adjusted to emit f-11 light.

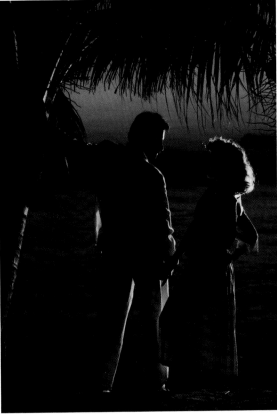

This pre-dawn scene proves that subjects' faces do not have to be displayed in order to produce strong images. This is especially true when such a photograph is one of many within a bridal album. The ambient light was underexposed by two full f-stops, using the shutter speed control. The main light was placed about 110 degrees to the right of the camera to outline the subjects.

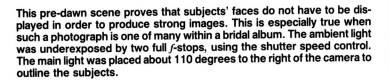

In this photograph, more information but a less dramatic effect were obtained than in the previous photo. The ambient light was underexposed by only one full *f*-stop rather than two. The main light was a Multiblitz fired through a four-foot soft box. This combination gave a softer feel to the overall lighting.

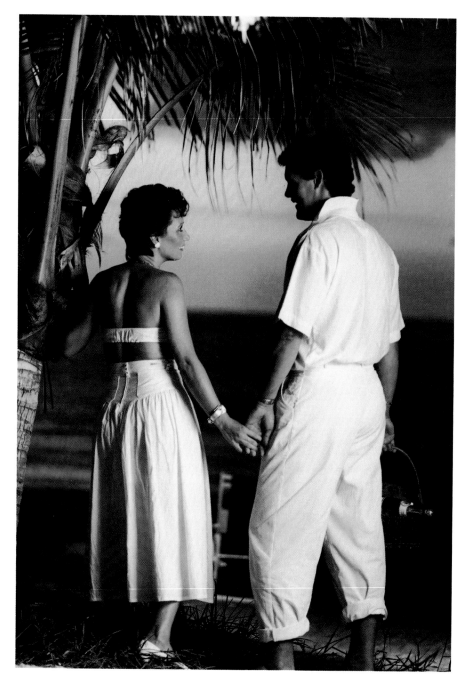

Although this was a sunrise photograph, it could be taken for a sunset scene. The couple has a look of togetherness and of single purpose. The warmth of the sky adds to the good feeling one gets from viewing such an image. It's a peaceful, tranquil image.

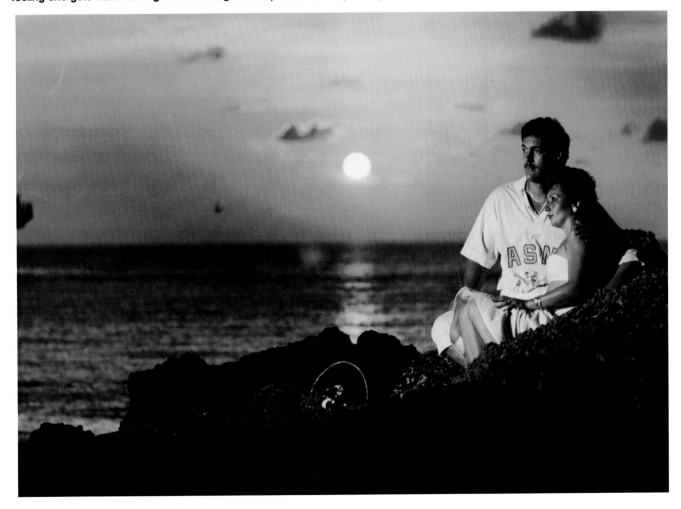

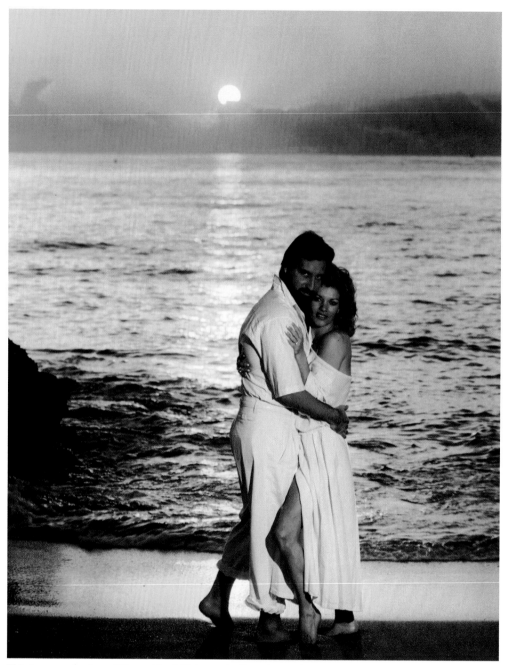

This image reflects well the subjects' intense feelings for each other. All poses will not fit all people. When necessary, you must be prepared to rapidly change from one pose to another. A couple may wait for you, but the sunrise will not.

4

Preparing For The Ceremony

The typical wedding involves a series of linked events. One of these is the dressing and preparation of the bride, her family and attendants. This is the *preparation* phase.

This phase usually occurs at the bride's home or the home of her parents, one to two hours before the ceremony. However, occasionally it will take place on the premises where the ceremony is to be held. Although this phase could apply to both the bride and the groom, it will nearly always apply to the bride only.

This will be a busy and hectic time for the bride and her family. Last-minute details must be attended to and there are always likely to be a few things going wrong. Flowers may be late in arriving, bridal clothing may not fit precisely, snaps and buttons may break, the bride's hair and makeup may not look correct, the limousine may be late, and so on.

Despite this chaos, brides often want selected photographs of the activities and excitement associated with this preparation.

VALUE OF THE SESSION

Wedding photographs should de-
pict the full story of the wedding day. Photographs of the bride, her family, and attendants preparing for the ceremony give this story its logical beginning.

Many photographers are fortunate in that their bridal subjects dress and have the ceremony and reception under one roof. In our area, we are generally not so lucky. For us, it is most common to have a bride schedule her dressing for one locale and the ceremony in a second, then drive to still a third area for the reception. This involves much time and the moving of much equipment.

Although the home photographs are important, they are not critical and they—by themselves—don't generally produce a high volume of photo sales. However, if you can combine photographs from this phase with some made using a portable background—portraits of the bride and groom, the bridal party and the immediate family members—picture sales can increase dramatically.

When a bride has initially selected a modest bridal package, and the preparation phase of the wedding will not occur under the same roof as the ceremony, you may elect to forgo
photographing this phase or charge extra for the additional time involved. However, if the bride will be dressing at the same locale where the ceremony is to take place and you can convince her to give you an additional hour or so before the ceremony, set up a portable background and studio lighting and photograph everyone in the bridal party in formal, portrait fashion.

These portraits will make a terrific addition to the bridal album, serve as excellent gifts from the bride and groom to the various members of the bridal party, and prove extremely strong sellers. Every time we have used a portable background at a wedding and have taken formal portraits of selected people from the wedding party, our photo sales have increased.

LENGTH OF THE SESSION

The amount of time you'll need to photograph the preparation phase depends upon two main considerations: Your own degree of preparation and the number of family and bridal party members that a bride has at the preparation site.

You must arrive on time and you must be ready to shoot the moment you arrive. If you are late or unprepared, it will cut back your effective photograpy time and, therefore, the number of photographs you will be able to take. The bride will still attempt to maintain her schedule and leave for the ceremony at her appointed time, even if you've not finished photographing.

The fewer the people, the faster you'll be able to photograph this phase. On the average, you should be able to take all the photographs you'll need in 30 to 45 minutes. In this time, get as much pictorial variety as you can.

Since you will be working on a tight schedule, you should choose your images carefully, making the most important and popular first and leaving the others for last. To make effective use of your time, have particular photographs in mind before you arrive at the preparation site. If the bride or family members suggest other poses, do them and then immediately continue with your planned photographs.

If the bride is dressing at the location where the ceremony is to take place, and if you are subsequently going to do formal portrait photography with the portable background, have an assistant set up all equipment needed for the formal poses while you are finishing with the preparation phase. Once that phase is over, you can escort the subjects to the area where your studio equipment is set up and begin your formal poses with minimal delay.

EQUIPMENT NEEDED

In the preparation phase, time and space will almost certainly be limited. So, limit the amount of equipment you bring along. Take two cameras, with a standard lens on one and a wide-angle lens on the other. This will allow you to shift from one pose to another with speed and ease.

Although you should *limit* the amount of equipment, be sure to take all the equipment you feel certain you will *need*. Once you have started photographing, you won't be able to excuse yourself, run to your car for other pieces of equipment, and return to resume photographing. In your absence you will have lost the attention and interest of the bride and all involved, as well as the time to take all of the required photographs.

Take a flash for each camera, plus an off-camera slaved flash in the event you have the space and opportunity to use dimensional lighting. Also take a tripod, a cable release and an incident-light meter for natural-light photographs. Other than film, no other equipment will be necessary.

When the preparation is at the location of the ceremony and you're going to employ the portable background, the studio equipment we listed in Chapter 2 should be used. If you're going to do only head-and-shoulder views of individuals or couples, a 6x6-foot, earth-toned background will suffice. It can be quickly setup and secured by two lightweight light stands and two clamps.

However, if you intend to photograph four or more people at the same time or do full-length views, a 9x12-foot or 9x18-foot background should be used, supported by accordingly heavier light stands.

A four-foot soft box will give good light coverage for even a moderately large group, as well as soft light for the tight head images. Although such a source will also put some light onto the background and help separate the subjects from it, an additional background light should be used whenever possible, to add a feeling of depth.

As a rule of thumb, the background light should be at a power setting either equal to that of the main light or at one *f*-stop less. The latter setting will afford a more dramatic look.

GET PERMISSION FOR LOCATION SHOOTING

If formal photography is to be done at the church because that's where the dressing and preparation are also taking place, it's imperative for you or the bride to arrange in advance the use of a suitable shooting space. Consult with the minister, priest or rabbi regarding where you might set up your equipment and portable background. If such photography is to be done where the reception is to be held, the people in charge there must be consulted.

Wherever the bride dresses, you must not presume that you automatically have permission to take in studio equipment or that you will have space in which to set it up. Ask permission and arrange for the space in advance. If you fail to do so, you could be in for some embarrassing moments, including your being denied the opportunity to take such photographs.

USE OF PORTABLE BACKGROUND

Use the portable background together with studio equipment to make most of the formal portraits. Photograph the bride, first alone, then with her maid of honor, and then with all her attendants. When you've finished photographing the bride, repeat the procedure with the groom, his best man, and then all of his ushers.

In addition, do individual photographs of each member of the bridal party, the groom's parents individually and as a couple, and the bride's parents individually and as a couple. Finally, photograph the bride and groom together.

If the bride and groom do not wish to see each other before the ceremony, you'll have to photograph them as a couple after the ceremony. In that case, however, you won't have time to set up studio lighting or the portable background.

Checklist for the Preparation Phase

The following list of poses is not exhaustive and is offered only as a guide until you have developed your own expertise and style:

1. Bride getting dressed or having her makeup applied.
2. Bride in full gown; a full-length shot.
3. Bride in full gown; a three-quarter or head-and-shoulders shot.
4. Bride with her mother.
5. Bride with her father.
6. Bride with both of her parents.
7. Mirror shot: bride and her mother.
8. Bride with her sisters and brothers.
9. Bride with her grandparents.
10. Bride with all of her family: mother, father, sisters, brothers and grandparents.
11. Bride with maid of honor.
12. Bride putting on garter, assisted by maid of honor.
13. Bride standing or seated near large window, illuminated by flash as primary light source.
14. Bride standing or seated near large window, illuminated solely by natural light.
15. Bride with her maid of honor and all of her attendants.
16. Maids of honor and their preparation, such as applying their makeup, fixing their hair, and so on.
17. If there are any children around, photograph them in preparation or in cute, happy situations.
18. Three-generation pose: the bride, her mother and her grandmother.
19. Bride, maid of honor, and all attendants leaving the preparation site.
20. Bride with her mother and father in front of the preparation site.
21. Bride getting into the limousine, assisted by her father, with her mother looking on.
22. All of the attendants, as a group, preparing to enter the limousine.

MUST-GET PHOTOGRAPHS FOR THIS PHASE

Although we have just itemized 22 photographs that could be taken for this session (and at least another 10 could come to mind), we consider only a few as essential, "must-get" photographs. The remainder will depend on the time and circumstances. The required photographs for this phase are as follows:

- The bride with her mother.
- The bride with her father.
- The bride with both of her parents.
- The bride with all of her family.
- The mirror shot: bride and her mother.
- Maid of honor assisting the bride with her garter.
- The bride at the window, illuminated by natural light.
- The bride with the maid of honor and all her attendants.
- Three-generation pose: the bride, her mother and grandmother.
- The bride getting into her limousine, assisted by her father, with her mother looking on.

Photos in This Chapter

Unless indicated otherwise, all of the photographs depicted in this chapter were taken with the following equipment and at the following exposure settings: Hasselblad camera; 60mm lens; one Vivitar on-camera flash attached to a specially designed flash bracket; exposure of *f*-8 at 1/60th second, plus flash adjustment for emitting *f*-11 light; a Minolta Auto 3F meter in incident-light mode for metering ambient light.

This scene was illuminated only by natural window light. The camera was handheld. A meter reading was taken at the bride's face with the dome of the incident meter facing the window. The meter indicated *f*-8 at 1/125th second and the film was exposed at *f*-8 at 1/60th second.

Because the bride was facing into the light, much detail on the front of the dress was lost. However, the pose and the details of her apartment strengthen the image. The reflection of the room and of the back of the bride in the mirror add rich dimension to the photograph. Natural window-light views, such as this, sell well.

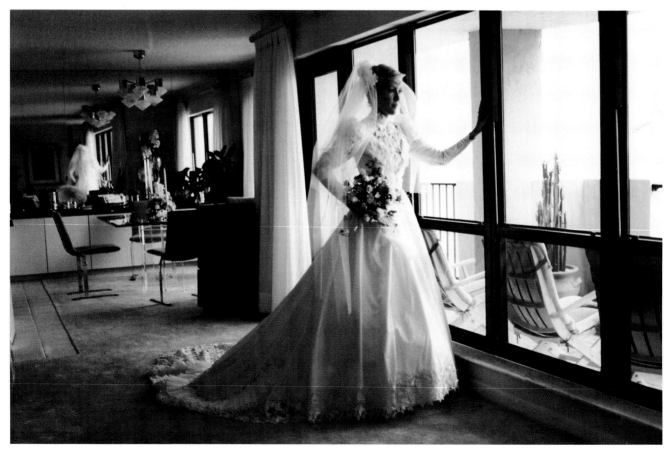

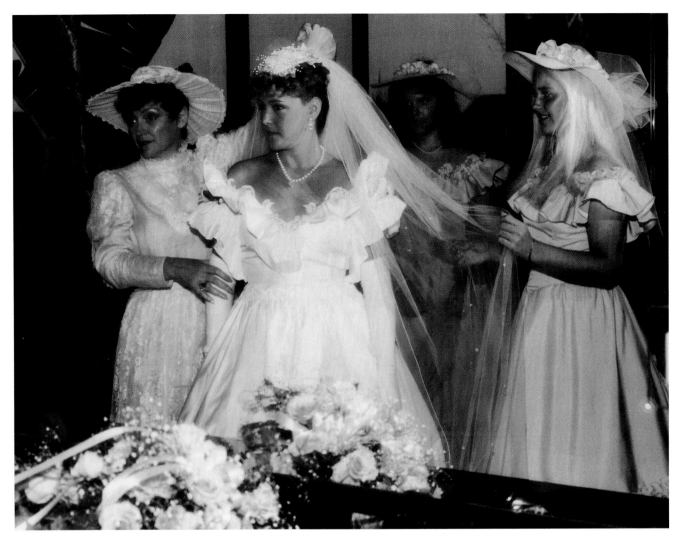

This bride was preparing herself at the home of her parents. At first glance, one might think this a direct view of a mother fussing with her daughter's veil, while two attendants look on. It's not; it's a reflected image. This is a mirror pose executed in the master bathroom of the home.

When making a mirror photograph, be sure not to include yourself and your camera in the picture. Have the mother act as though she is doing something to the bride's gown. Also, be sure to focus on the image that's reflected in the mirror and not on the mirror itself.

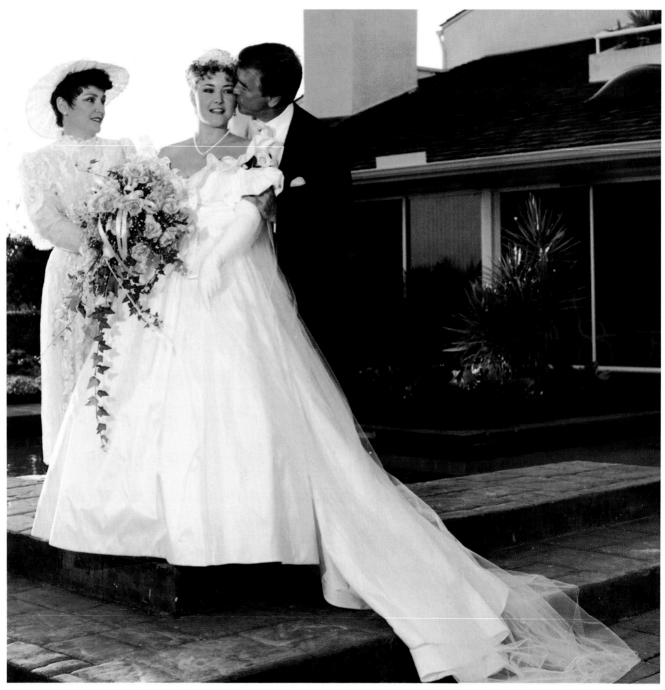

Poses in the preparation phase should always include one of the bride with her mother and father. Unlike a traditional pose in which all three subjects are standing formally and looking directly at the camera, this outdoor pose appears more natural. Although the interior of this home was beautiful and a number of photographs were taken there, the grounds afforded additional photographic potential. Never pass the opportunity to capture the environment. It helps to remind the subjects of where they were when a particular photograph was taken, making the image more meaningful and more saleable.

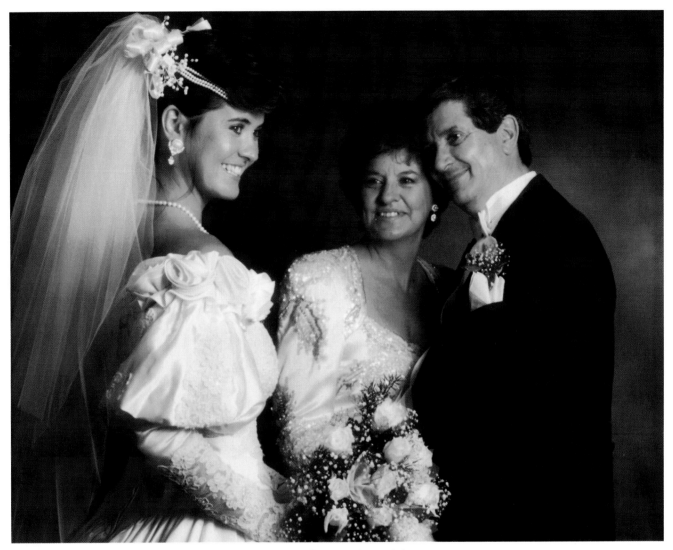

For this view, a portable 9 x 18-foot background was used. One four-foot soft box was used as main light source. Time and space did not permit adding a fill light, reflector or background light. The point of focus was on the bride, which caused the image of the bride's parents to go soft. This effect heightened the mood of the photograph.

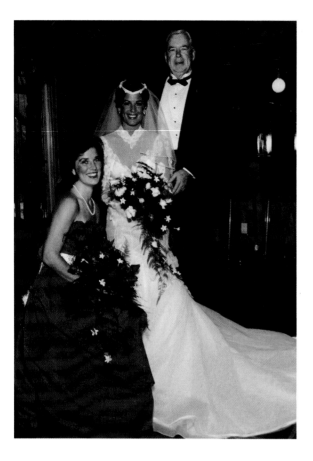

Avoid having subjects all stand or sit in a straight line. It results in a boring photograph. In this image, all three participants—the bride, her sister and her father—were posed at different levels but in the same plane of focus. By varying the heights of the subjects, an ascending line was produced that strengthened the composition. Keeping the subjects in the same plane of focus reduced any depth-of-field problems.

When space is limited, don't hesitate to seat the bride and her maids. In order to make the bride a bit more prominent, let her sit on a pillow. If possible, take advantage of anything in the room that might reveal something about the subject. It will make the shot more attractive and meaningful.

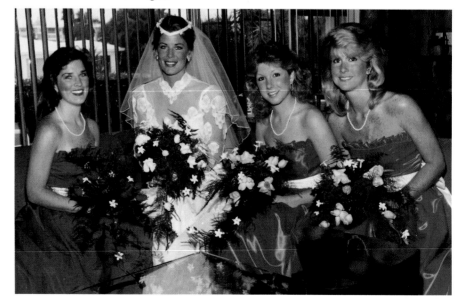

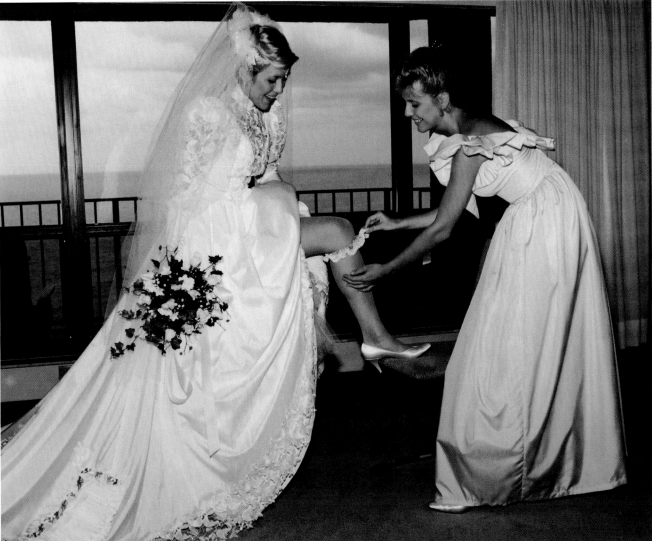

When taking the garter photo, keep the bride and the maid of honor in the same plane of focus. If one of the subjects is closer to the camera, she will become more prominent and defeat the purpose of the image. In our image, both subjects are of equal size and the prominence therefore shifts to the most important item, the garter. The drapes were intentionally allowed to remain open. The bride loved the view she had from her apartment.

An incident-light meter reading was taken at the window, with the dome of the meter facing the ocean. It indicated an exposure of f-8 at 1/60th second. The camera was set to f-8 at 1/125th second to underexpose the outdoor scene. The on-camera flash was adjusted to emit f-11 light.

A photograph of this kind should always be taken from the side where the garter is. In other words, if the garter is on the bride's right leg, that is the side the camera should be on.

same plane of focus = equal distance from the camera

In this view, the bride was seated on the arm of the couch and the maids seated all around her—but each at a slightly different height, to make the composition more interesting. The ambient light was carefully metered in order to show all of the artifacts and the interior of the bride's apartment.

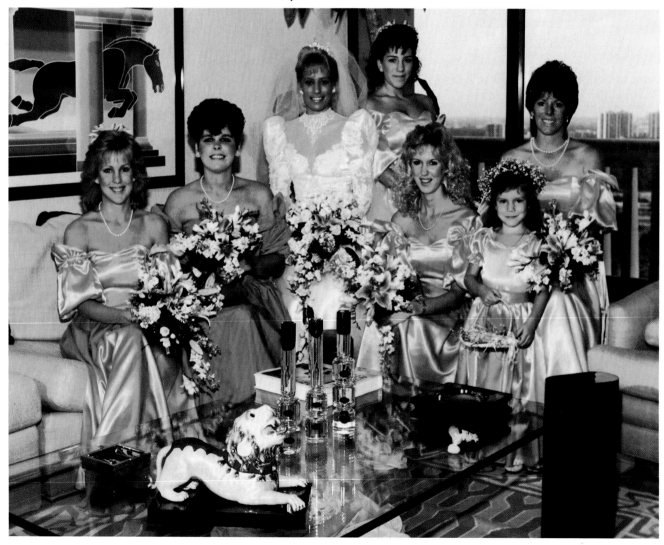

This is another example of using the 9x18-foot portable background. The photograph was taken at the church where the couple were to be married. The groom and all the ushers dressed at the church. After we had finished photographing the bride, her attendants and her family, we photographed the men. Two 4-foot soft boxes were used, with the fill light adjusted to put out one *f*-stop less power than the main light. Space did not permit adding a background light.

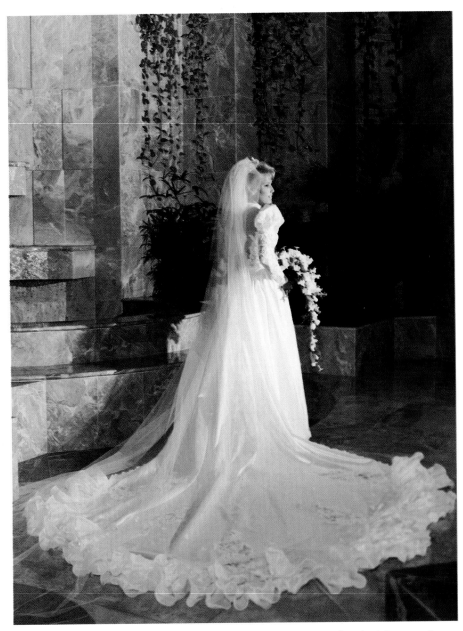

Even if the place where the bride is dressing is ideal for photography, don't ignore other potential surroundings. This lobby, for example, afforded an excellent area for taking full-length photographs of the bride. The background added to the composition. One off-camera, portable flash was used as the main light, with the on-camera flash—set at one-half the power of the main source—acting as the fill light.

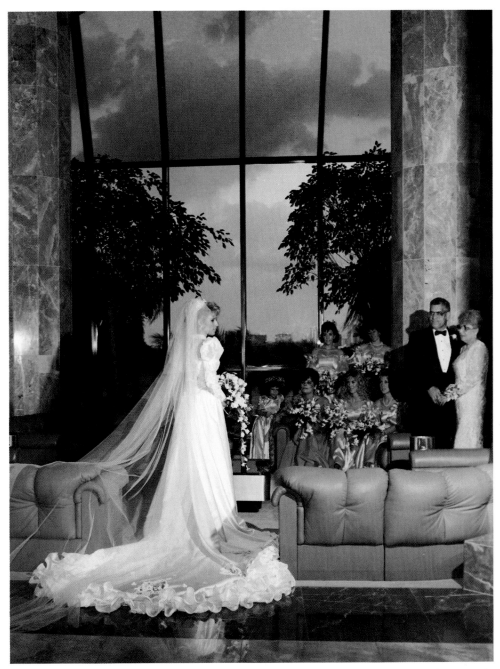

When you are photographing a wedding, be aware of everything happening around you. Photographic possibilities will be everywhere. While this photo was being made, the bride's parents and all of her attendants watched. Without disturbing them, we moved the bride close to the group and made this photograph, using the same light setup as in the previous photo. Both images became popular additions to the bride's album.

This photograph depicts the bride and her immediate family: mother, father and two brothers. It's the kind of photo that always sells. After the ceremony, a similar photograph was taken, but one in which the groom and the wives of the bride's brothers were included. That sold, too. During the course of the wedding day, attempt to take at least two different photographs of the bride with her immediate family, and of the groom with his.

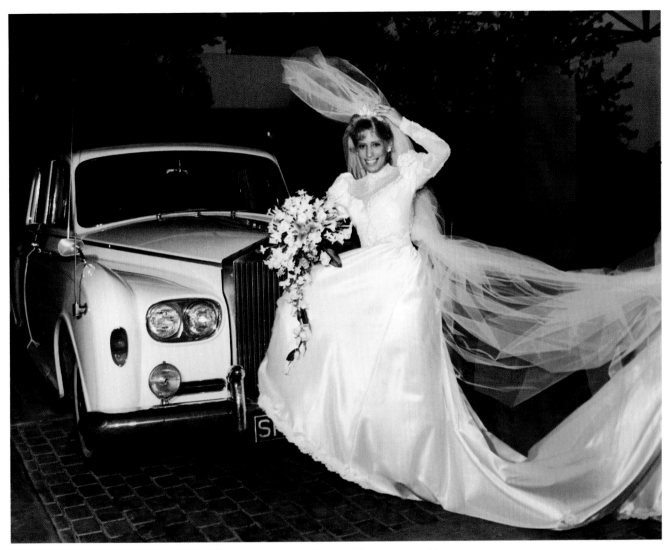

Be on the constant lookout for cute things happening at a wedding. In this case, the bride was trying to get to the limousine to leave for the ceremony but the wind was very strong, forcing her to struggle with her headpiece and veil. She kept her sense of humor and offered a smile. Photographs such as this offer a pleasing relief from the traditional poses.

There are a number of ways to photograph a bride entering a limousine. The way we like to do it is from the rear of the car. This puts the open door at the bride's back, giving an uninterrupted view of the bride and her gown. Typically, the bride should be assisted by her father, with her mother looking on. For this photograph, the bride's father was not available, so her sister was substituted. It is not necessary to show the entire length of the car in the photograph as long as the style of the car can be identified.

Taking photographs of the bridal limousine by itself, without the bride or other members of the bridal party, is a waste. Generally, such photographs are meaningless.

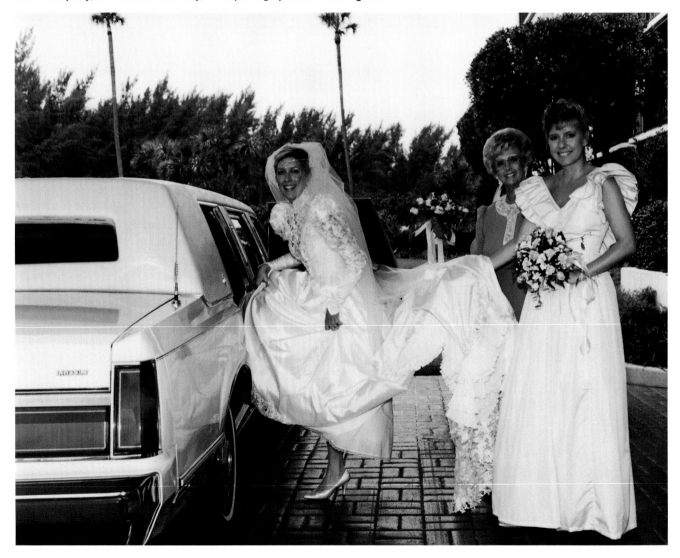

The Ceremony

This is an extremely important and critical photographic phase of any wedding. It involves photographs of people and activities before, during and after the actual wedding service. Although the ceremonial procedures will vary from one wedding to another because of religious differences, there are common threads that run throughout almost all weddings. This chapter addresses itself to them.

As with the preparation phase, the ceremony phase will be a hectic time. Everyone participating in the actual wedding will exhibit some degree of nervousness, and many will not know exactly what to do or when to do it. Your inclination will be to take charge, but don't do it.

Assist if and when you can, but don't orchestrate, except in relatively minor matters. For example, you may think that photographs would look great if the people in the bridal party walked down the aisle one couple at a time rather than individually. Nevertheless, if the person selected to officiate at the ceremony—the wedding official—has instructed them to proceed individually, you must accede.

Until the actual wedding service is over, there will be little opportunity for you to take charge. The wedding official will be in almost total control and you must not issue instructions that might be contrary to his wishes or policies.

However, this is not the time to relax or slacken in your responsibilities. On the contrary, since the wedding official will be in control, you'll have to be more alert than ever in order to work according to his rules and still take the photographs you must get.

No matter where the ceremony is to take place—in a church, temple, hotel, country club, home or backyard—you must maintain a constant sensitivity to all events around you. You must not become overwhelmed by the grandeur of the location or of the participants themselves, or too enraptured by the moment. You are not at the ceremony as a spectator or guest but to photographically capture the events and emotions involved.

The Seven Parts of the Ceremony

From our experiences at all the weddings we have ever photographed, we have concluded that, for a photographer, the ceremony phase has seven parts. It will assist your handling of this phase if you keep those parts in mind, as listed here:
1. Discussion with the person officiating at the ceremony.
2. Events preceding the processional into the church.
3. The processional.
4. The ceremony.
5. The recessional.
6. The receiving line.
7. Re-enactment of the ceremony.

A TALK WITH THE OFFICIAL

When you first arrive at the ceremony site, it is imperative to seek out the person officiating at the ceremony, whether he be a priest, minister, rabbi, judge or someone else. Let him know who you are and why you are there. Advise him that you are interested in knowing all of his rules regarding photography at the wedding. Let him know you intend to conduct yourself in a professional manner and do nothing to cause him, his institution, or any of the people in attendance at the ceremony any embarrassment or delay. He'll appreciate your professional manner and generally give you whatever assistance you require.

This approach is just good busi-

ness. In the beginning of your career, you will not know all of the officials at all the ceremonies you attend. In time you'll get to know them, and they you, and a rapport will develop. They will learn to trust you and your work and allow you photographic license without any prior conversation. Until that time, get into the habit of asking first before you photograph.

Your discussion with the official should include the following topics:
1. Level of light for the altar.
2. Length of the ceremony.
3. Restrictions on photography during the service.
4. Restrictions on your movements during the service.
5. Off-limit areas.
6. Recreating parts of the ceremony.

Level of Light on the Altar—No matter where the service is to take place, there will generally be some form of altar, and some form of illumination on it to distinguish it from the surrounding area. The lighting on the altar, as you first observe it, may not be the same that will be used for the service. Ask the official. He'll know.

Since you will be doing some available-light photography from the rear of the church or temple during the service, you must know what the light level on the altar is going to be. Meter that light in advance. Taking light meter readings only from areas adjacent to the altar will not suffice. Your concern is primarily with the lighting on the altar itself and only secondarily with the surrounding area.

Length of the Ceremony—Some ceremonies are short and others quite lengthy. Unfortunately, such vague time references are not sufficient for wedding photographers. More precise information is required.

Some officials try to satisfy you with remarks such as, "The ceremony will be quick" or "It won't last very long" or "It'll be a little while." Don't accept these answers. You need to

know more definitely. Ask the official for his best estimate, in minutes.

But whatever you do, and no matter what time period is told to you, until you know how that particular official conducts his service don't take his information as accurate. Use it as a guide only.

We have photographed many weddings at which the official told us the ceremony would last 30-40 minutes, only to have it last only 15. You don't want to be at the rear of the ceremony site, doing available-light photography, with your flash detached from the camera and your camera mounted on a tripod and suddenly learn that the service is over and the bride and groom have just kissed and are about to walk back up the aisle. You will miss a great many of the required photographs.

Restrictions on Photography—Generally, the actual wedding service does not officially start until after the processional has ended. We shall discuss and define the processional below.

Nevertheless, some churches and temples will not permit any form of photography, even with only available light, once the processional starts. At other locations, you may be allowed to photograph the processional and recessional. Photographs of the actual service will nearly always be limited to available-light photography and from restricted areas, such as the rear of the chamber.

Some officials won't permit photography during the service even when it is being held at someone's home, a hotel or a country club. Right or wrong, you must accept these restrictions and arrange to take all of your required photographs after the service is over. In addition, make sure you report these restrictions to the person who hired you and give assurance that you will do all of the needed photography after the ceremony has ended.

Whatever restrictions are imposed, heed them well. For example, if the official says you can take photographs near the back of the church, adjacent to the first or second row of seats, don't try to photograph from mid-church. If he allows one photograph of the groom placing the ring upon the bride's finger, don't take three or four.

Restrictions on Movements—Many officials dislike the idea of people moving about once the ceremony gets under way. In such cases, the official will give you his guidelines and expect you to conform. As before, heed his instructions carefully. If he allows available-light photography from the rear of the church, don't view this as license to take similar photographs 10 feet from the altar. If this is what you want to do, ask permission first. Without advance permission, we would not hazard any form of flash photography once the service has started.

Off-Limit Areas—If you are given permission to photograph during the service, you must find out in advance what areas in the church or temple are off-limits to you. A number of religious institutions have lofts or second floors that lend themselves to wide-angle, available-light photography. Don't presume you have access to such areas simply because you are given permission to photograph the service. Ask first. Also, don't presume you have permission to go to the altar once the service has started. Most often you're not permitted to do that and all photography will have to be done from the aisle or side areas.

If you haven't inquired about the off-limit areas in advance, use good judgment and be as inconspicuous as possible. Do nothing that might cause embarrassment or distraction. Officials have told us stories of ill-trained, non-professional photographers who have literally suspended themselves from raised pulpits just to capture that

"unusual shot" during a service. Such photographers make it hard for the rest of us.

Re-creating Parts of the Ceremony—Generally, no matter where the ceremony takes place, if the official has not allowed you to photograph during the service, he will help you re-enact any portion of it you wish afterward. However, he may forget his promise to you and leave after the service. To help avoid this, immediately after the service is over, remind the official you'll need him for three or four photographs and assure him you will work quickly so as not to delay him.

EVENTS BEFORE THE PROCESSIONAL

After you have talked with the official, immediately find the groom and the best man. Usually, they will be tucked away in a waiting room near the altar, away from the sight of all.

Take a couple of photographs of the groom alone and then a couple more of him with his best man. Watch your backgrounds carefully. In most churches or temples, the waiting room will not be attractive. If it is too bad, move the subjects into the hallway or even outdoors.

Often this will be your first meeting with the groom and the best man. Make your introductions, congratulate the groom and let him know that you are there for the entire wedding and to do whatever photography he and his bride wish.

Once the groom and his best man have been photographed, go back to the rear of the ceremony site and await the bride's arrival.

If the church or temple does not have an adequate waiting area for the bride, she will often wait outside, in her limousine, until all the guests have been seated, just prior to the start of the service. Whether she waits in the car or inside the church or temple, it is important to take photographs of her leaving the car, walking up to the building and, once inside, being fussed over by her attendants and mother.

This is a good time to photograph the ring bearer and flower girl, the bride's father kissing the bride, the ushers having their carnations being pinned on, and numerous other situations.

Don't take boring, meaningless photographs. Look for strong emotion, perhaps tears of joy, before you snap that shutter. Such photographs will outsell any in which a subject is staring blankly at the camera.

THE PROCESSIONAL

Once the guests have been seated and the time for the service is at hand, the bride, her father and all her attendants will line up at the rear of the church or temple to begin their walk down the aisle to the altar. This is called the *processional* and signifies the official beginning of the wedding ceremony.

Before the processional, as the time for the service approaches, some of the last people to be seated by the ushers will be the grandparents of the bridal couple, the parents of the groom and the mother of the bride. All will usually be seated close to the altar, in the first or second row. After the seating of these family members, all the ushers will move to the front, near the altar, to meet the groom and best man.

If you have an assistant, instruct him or her to photograph the bride, her father and the attendants as they prepare to form their line. The last few anxious moments for these people can yield some very interesting and attractive images.

In addition, the assistant can ensure sufficient time intervals between the people as they walk down the aisle, to make photography possible. We suggest that at least five or six seconds are necessary for each shot.

If people are too close together, you may have time to photograph only a few, which is not acceptable. You must take at least one photograph of each attendant.

The bride and her father will always be the last to walk down the aisle. Of all the photographs taken during the processional, the most important are those of the bride with her father. Take at least two, from different distances, to give the bride a choice and to ensure a good expression.

When the bride and her father reach the foot of the altar, the father will lift the bride's veil and kiss her. She will then take her place next to the groom. The father will retire to be seated next to the bride's mother. The groom will escort the bride to the altar and both will stand before the official. The processional will be officially over and the service will have begun.

If flash photographs during the actual service have been prohibited, you must stop photographing and retire to the rear of the church to take your available-light photographs.

THE CEREMONY

After the couple step up to the altar, the official will usually have some type of speech prepared for them and the audience. The couple will then exchange their wedding vows, the official will give a blessing over their rings. The groom will put a ring onto the bride's finger and the bride will place one onto the groom's finger. The official will bless the couple, pronounce them man and wife, and allow them to kiss. The official service will then be over. The couple will turn and face the audience and the official will introduce them as Mr. and Mrs.

As the couple stand at the altar for a few seconds while this introduction takes place, you will have a perfect opportunity for your first photograph of them as a married couple. They will then leave the altar and walk to

the rear of the church.

The information just provided is intended as a guide only. Ceremonies can and do differ. However, our information should be helpful at almost all weddings.

THE RECESSIONAL

Once the bride and groom have turned to start their walk back down the aisle, the recessional phase of the ceremony will have begun. The couple will be followed by all of the bridal party, their parents and grandparents.

The major difference between the processional and recessional is that in the former it is customary for the bridal attendants to walk to the altar unescorted, whereas in the recessional each attendant will be escorted by an usher.

As with the processional, photography timing becomes critical. There will be a tendency for the bridal party to scurry up the aisle, relieved that the pressure is over. In the rush you may not be able to photograph each couple. Photographing only some of them is not really sufficient. However, whether you photograph the entire recessional or not, the photographs you must not miss are those of the bride and groom. Take at least two or three, varying your distance from them.

If you have an assistant with you, post him or her near the altar to ensure that all the couples walk back down the aisle in an orderly fashion. Whatever you do, whether you have an assistant or not, do not stop the progression of the recessional. We have heard complaints about photographers stopping couples in the middle of the aisle while they focus, load film or pose the subjects. People will begin to bunch up and a minor jam will occur. If you have missed some photographs, attempt to re-enact the event later.

Although, in our experience, brides seldom buy photographs of both the processional and the recessional, we photograph both—to ensure good images of at least one of them.

THE RECEIVING LINE

Photographically speaking, this is not a useful part of the occasion. The bride, the groom, each member of the bridal party and the bridal couple's parents will all line up—inside or outside the church or temple—and greet each of their guests. Good photography is difficult. As often as not, you'll be photographing someone's back. Once in a while, you will be able to get a side view of the bride or groom kissing or hugging their respective grandparents or special relatives, and such images will sell. But a photograph of the bride hugging or kissing a guest, or of the groom shaking hands with someone, will not generate much interest.

If you are fortunate, the receiving line will be held outdoors, permitting a wide-angle photograph of the event. Such a general view will usually sell.

There is an interesting condition that sets in immediately after the recessional and just before the receiving line forms. We term it "down time" and it will last only a minute or so. As the bridal couple, their parents and the members of the bridal party congregate at the rear of the ceremony site, relief comes over all of them and they begin to hug, kiss or congratulate one another. This is a great opportunity for candid photographs that will display strong emotion.

RE-ENACTING
THE CEREMONY

If you were not permitted to photograph the wedding service, then the re-enactment part of the ceremony phase is a "must." If you were allowed to photograph the service, the re-enactment part is optional. You may elect to re-enact one or two scenes to ensure photographs with better angles, lighting or expression.

For the re-enactment part you'll need the participation of the wedding official for a few of the poses. This time you will have total control, so take charge. Time will be a factor, because the official will be anxious to leave and the bride's parents and all of the bridal party will be standing nearby awaiting the next phase of the wedding—photography at the altar. They will also be anxious to leave for the reception, to have fun and be with their guests.

Despite the time pressure, try to use off-camera dimensional lighting for as many of the photographs as is feasible. Be creative and spend an extra few seconds paying attention to details. The result will be more dramatic photographs that will appeal and will sell.

Checklist for the Ceremony

The following checklist of photographs is offered as a guide. You can expand it or subtract from it according to the circumstances of a particular wedding.

1. Bride and father leaving the limousine in front of the church.
2. Bride by herself, full-length, inside the church's waiting area.
3. Bride being fussed over by her attendants or parents.
4. Groom by himself.
5. Groom with his best man, shaking hands.
6. Groom with his father.
7. Groom with both parents.
8. Boutonnieres being pinned on the groom, best man and ushers.
9. Ring bearer and flower girl.
10. Grandparents of the bride, being seated.
11. Grandparents of the groom, being seated.
12. Parents of the groom, being seated.

13. Mother of the bride, being seated.
14. Soloist or harpist, if hired to play.
15. Groom and ushers standing at the altar, awaiting the processional.
16. Bride's mother waiting for her daughter to walk down the aisle.
17. Individual photograph of each bridesmaid, flower girl and ring bearer as each walks down the aisle.
18. Bride and her father walking down the aisle: One photograph from about 15 feet away; a second photo from about 10 feet away.
19. Father giving bride away to groom and kissing the bride.
20. Available light photography from the rear of the church or ceremony hall.
21. Back view of the bridal couple as they kneel or stand before the official.
22. Back view of the bridal couple as they receive a blessing from the official.
23. Lighting of candles by the bridal couple, if applicable.
24. Ring exchange between the couple.
25. The kiss between the couple.
26. Recessional images: Two of the bridal couple as they walk back down the aisle and one of each couple in the bridal party, plus the parents and grandparents of both the bride and groom.
27. "Down time" shots, described earlier.
28. Receiving line.
29. Re-enactment of service, if applicable.

MUST-GET PHOTOGRAPHS FOR THIS PHASE

Of the 29 situations listed above, only 10 are considered by us as "must-get" and they are as follows:
- Groom by himself.
- Groom with his best man.
- Groom with both of his parents.
- Parents of the groom, being seated.
- Mother of the bride, being seated.
- Processional images: An individual photograph of each member of the bridal party in the walk down the aisle, and the bride with her father.
- Ring exchange between the bridal couple.
- The kiss at the altar.
- Recessional image: the bridal couple.
- Re-enactment of the ring exchange and the kiss.

Photos in This Chapter

Unless otherwise noted, all of the photographs depicted in this chapter were taken with a Hasselblad camera; 60mm and 80mm lenses; one portable flash attached to special on-camera bracket; camera exposure setting of f-8 at 1/60th second and flash adjusted to emit f-11 light.

Whenever the ceremony site will not lend itself to good photography, don't hesitate to move your subjects outside. Take advantage of any attractive surroundings available. Photographs such as this one, of the groom with his best man or with a family member, should be taken before the start of the service. Although the subjects are posed, they look relaxed and natural, and the image is attractive and will sell. The shutter speed was adjusted to one f-stop below the indicated meter reading, to darken the ambient light. One portable flash was adjusted to emit f-11 light. The camera was set at f-8, for deliberate overexposure of the color negative film.

At some weddings, you will find the bridal party includes children. They will usually be very cooperative and make good subjects. Take advantage of any prop the ceremony site offers, as we did for this photograph of three boys around a staircase. Having the subjects involved with a prop keeps them from becoming too static and makes the image more appealing.

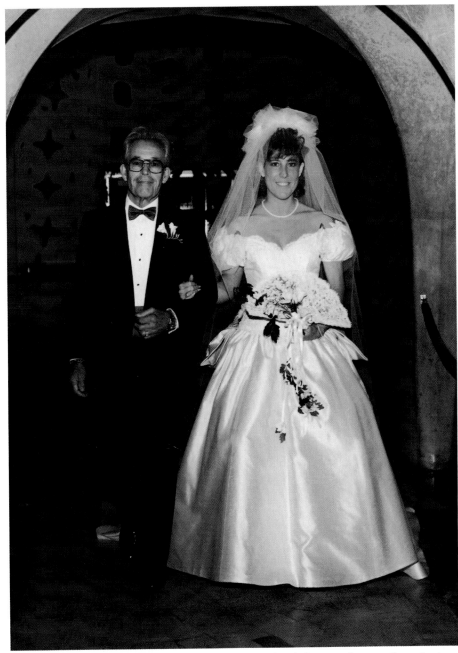

This photograph was taken at a church where processional photography was allowed only from a restricted area—the rear of the church. It would have been better to show the bride and her father walking down the aisle with guests on either side of them—a photograph from mid-church. However, the pride and joy in the father's face and the beauty of the bride made this candid image strong and saleable. Processional photographs such as this one are a must.

Once the father of a bride has escorted his daughter to the front of the altar, just before she takes her place next to the groom, you may see him kiss his daughter and shake hands with the groom. If you are allowed to photograph this part of the ceremony phase, don't miss this opportunity for strong, emotional images. They make a great contribution to any bridal album.

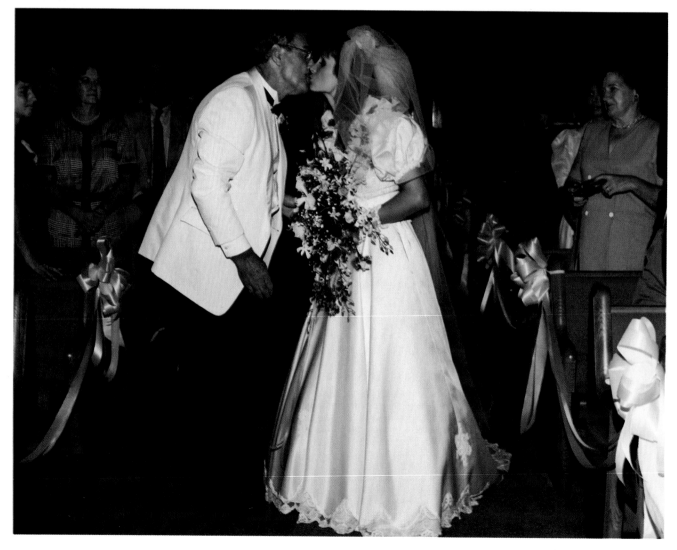

Whenever you have the opportunity to engage in available-light photography during the service, do it. The results will be stunning, saleable prints. The more you change your angle of view, lenses and filtration, the more variety you can offer. In the following six examples, a meter reading was taken at the altar, prior to the service. The camera was set at an *f*-stop and shutter speed that gave one full *f*-stop of exposure over that indicated by the meter. As we have indicated elsewhere, this overexposure is recommended only with color negative film. With color slide film, intended for projection, it's much better to underexpose slightly, to ensure good color saturation. Because such photographs generally require long exposures, a tripod and a cable release should be used. Several photographs of the same scene should be taken in case the principal subjects have moved and blurred one of the images during the long exposures.

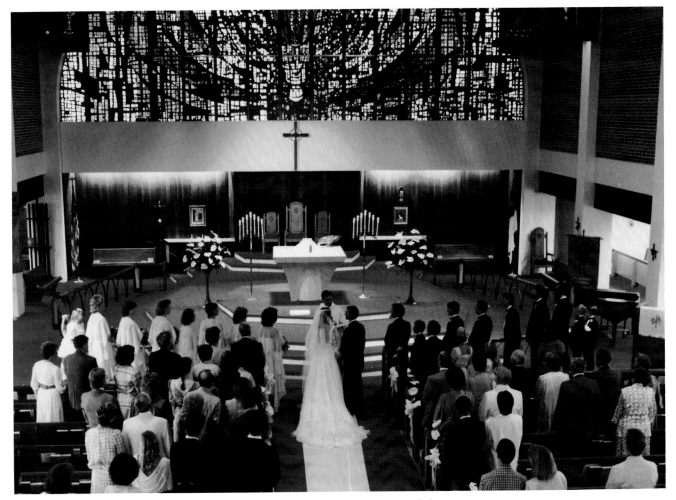

A balcony photograph, taken with a wide-angle or standard lens, gives a good overall view of the service. It serves to document or memorialize the event.

This photograph was taken from a low camera angle and from the rear of the temple. No flash photography was permitted at this wedding so all photographs of the service were taken with available light. A 250mm lens was used on the Hasselblad, together with a four-point star filter. The relatively long lens permitted an intimate view, and the filter gave an ethereal touch to the scene.

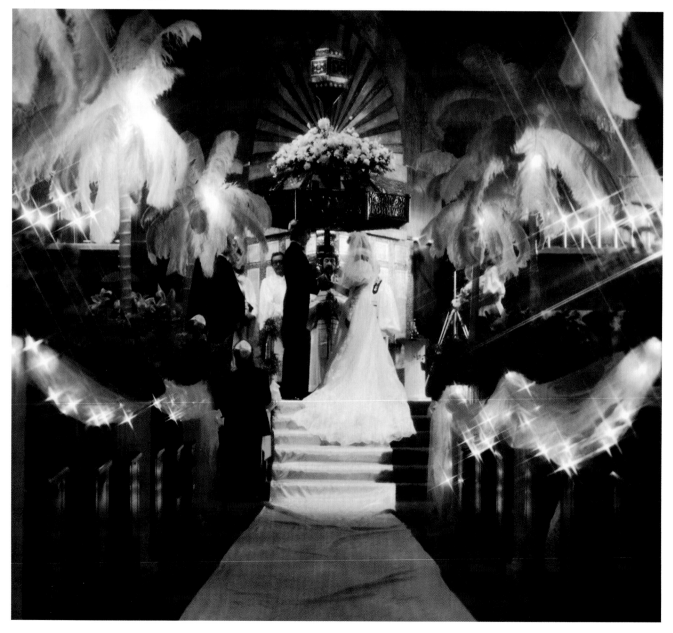

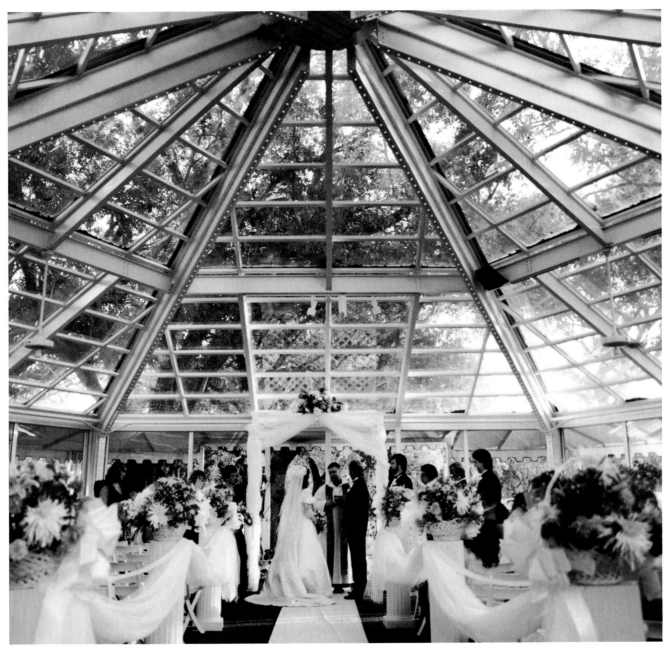

Whether indoors or out, when you are doing available-light photography of the service, have some images show as much of the overall scene as possible. They will help to record the events of the day and, therefore, will sell.

This photograph was taken from the rear of the church with available light. Its intimate appearance and ethereal quality were obtained by using a 250mm telephoto lens and a star filter. People love the effect of the star filter. It adds a dream-like, magical quality to most scenes and enhances those that might otherwise appear bland. The altar in this view was illuminated by tungsten light and candlelight.

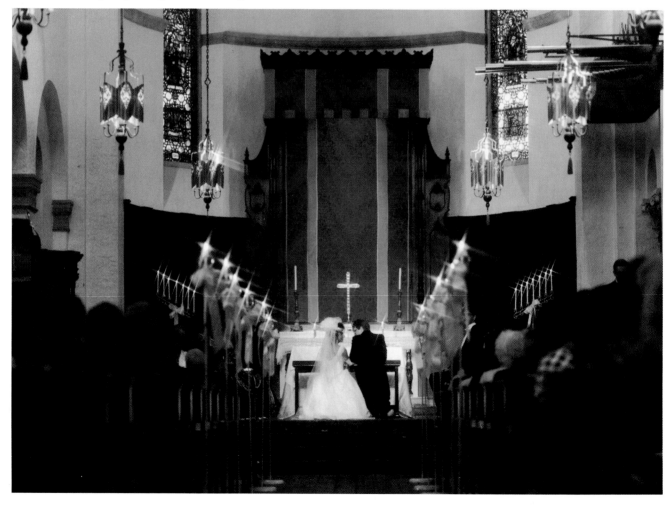

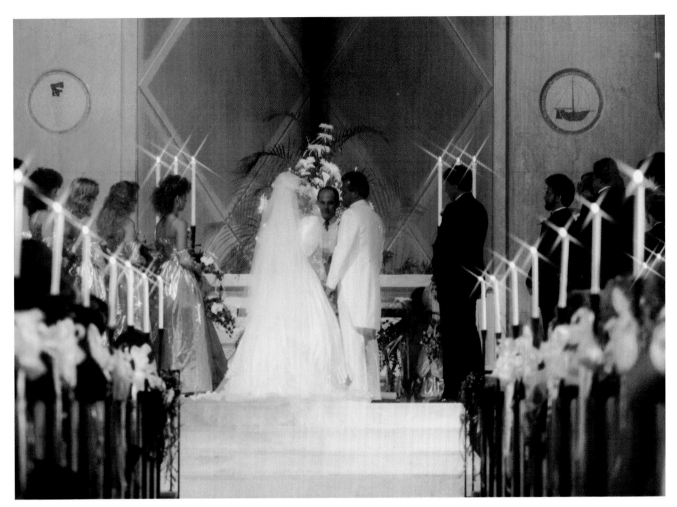

In contrast to the altar in the preceding photograph, this one was illuminated primarily by natural daylight. A totally different atmosphere in the photograph resulted. We used a four-point star filter. If time permits, attempt to do several available-light shots when the subjects are in different positions. This affords pictorial variety and an opportunity for a more expansive wedding album.

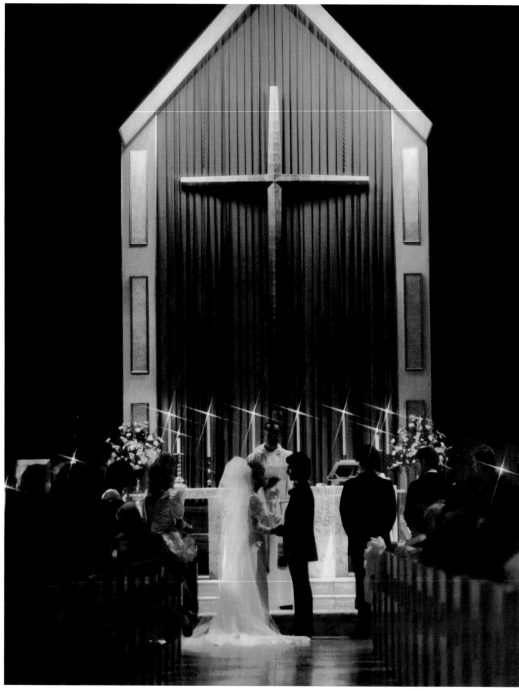

The intimacy of the occasion and the warm atmosphere of the scene were enhanced by the effect provided by the star filter.

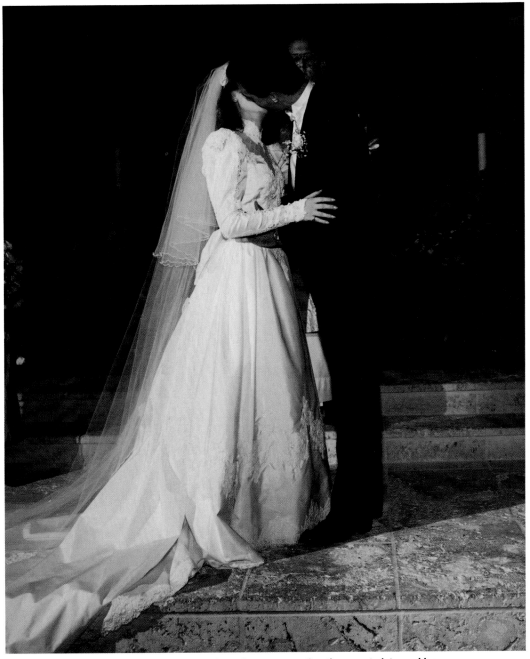

Whether you are photographing the actual service or recreating the events later, a kiss photograph is a must. In this image, made at the end of the service, neither face is seen. It doesn't matter. It is part of a series of photographs in a bridal album and the subjects know who they are. You will not be able to orchestrate such photographs, so take what you can. Later, if you wish to get a better kiss image, perhaps from a different angle or with different lighting, do so. This will give the bride a choice. Although you provide such a choice, often she'll choose the photograph of the "real thing" over the later, more formal pose, even if either one or both of their faces are hidden.

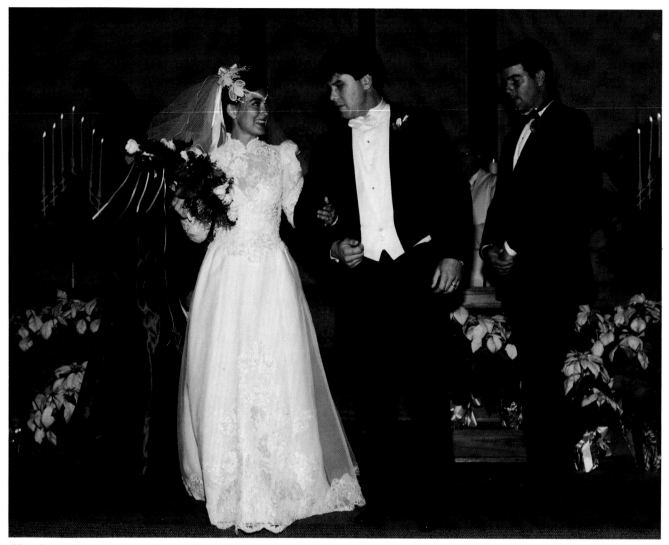

After the service is over and the wedding official has introduced the bridal couple as **Mr. and Mrs.**, there will be a brief moment before they begin their walk back up the aisle. At that time, you may be able to capture looks or expressions that should not be left unrecorded. Such was the case here.

Whether it be processional or recessional, don't pass up the opportunity to record emotions. The determined look on this young man's face as he returns from the altar during the recessional is a winner.

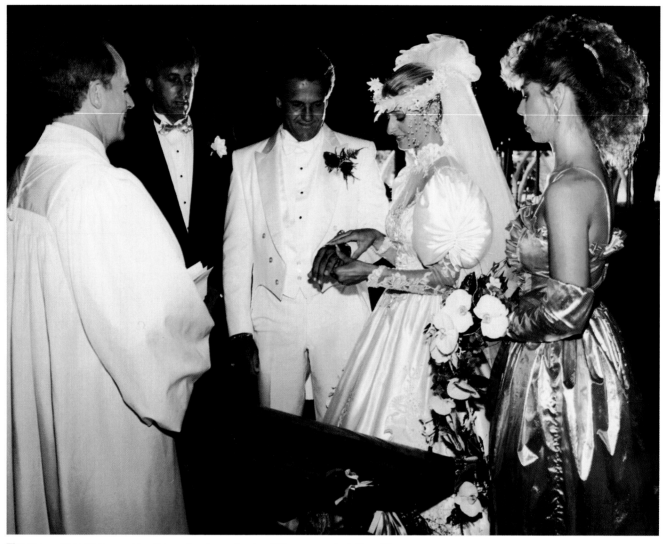

The ring exchange is a must-get event and usually should be re-enacted. Even if you were allowed to photograph the service, you will have been restricted to the foot of the altar and your camera angle may not have been the best. After the service, you'll be permitted on the altar dais and you'll have an opportunity of getting more detail into your photograph. If it is a double ring service, make sure that you have photographs both of the groom putting the wedding ring onto the bride's finger and of the bride putting the groom's ring onto his finger.

During many services, there will be a lighting of candles. Even when you are permitted to photograph this as it happens, you may still have to re-enact it. Often the hands or arms of the couple will block one or both of their faces, and this is not acceptable. If you are in doubt as to whether both faces clearly showed in the original shots, re-enact the scene after the service.

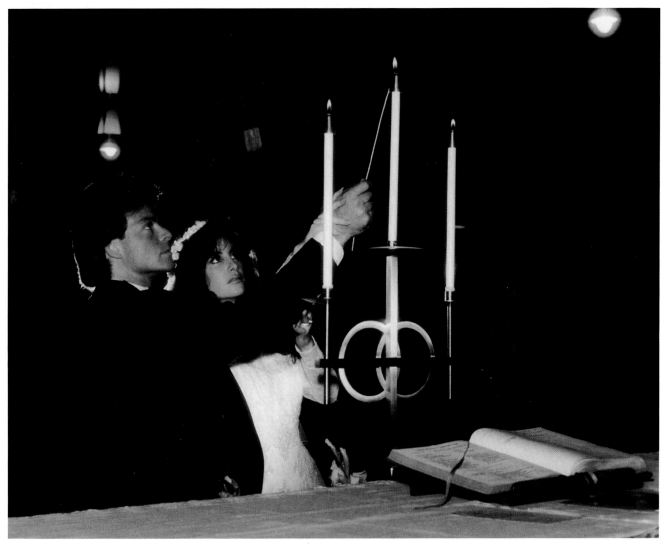

When re-enacting the kiss, don't pose the bridal couple too much. Let them adopt a position comfortable for them.

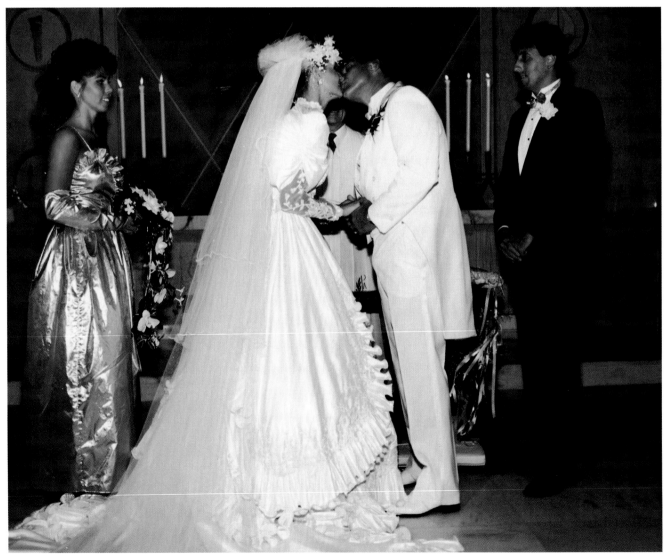

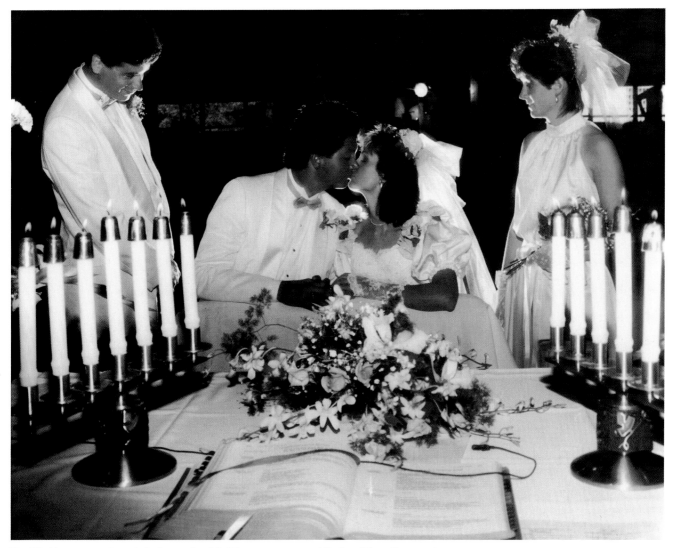

For this kiss re-enactment photograph, all lighting was arranged first and then the couple was instructed to kneel and kiss. In addition to the on-camera flash, one portable slaved backlight was used for added dimension.

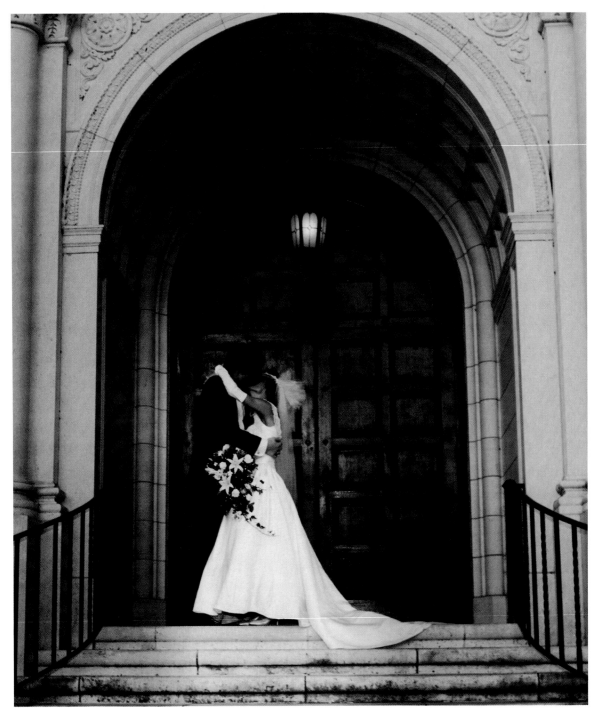

This image was made by available daylight only. The lamp in the center of the arch was switched on, to add a warm, welcoming glow to the scene.

Back To The Altar

When the actual wedding service and recessional have been concluded, the bride, the groom, their parents and grandparents, brothers and sisters, spouses and children of their brothers and sisters and the entire bridal party are asked to return to the altar for formal photography.

The Key Photos of the Entire Wedding

The most important photographs of the entire wedding are usually taken during this phase, known as the *altar returns*. Of all the photographs that brides purchase for their album, altar return photographs head the list. The process involves photographing individuals, couples and groups at the ceremony site, and specifically at the altar. Shooting time is usually limited, so the photographer must be able to work fast.

Many of the posed photographs will be traditional, environmental images, with the altar as background. This means that certain images will appear similar to most wedding photographs that we are accustomed to seeing. The poses are accepted in wedding tradition as standard poses and brides, and especially the mothers of brides, want to have them. You'll be expected to have the knowl-

edge and the ability to produce them.

This does not mean to say that you should not be innovative and creative. You should! However, it does mean that you must do some traditional photography first and then, time permitting, turn to more contemporary images.

This phase of the wedding day makes the greatest demand on the professionalism of the wedding photographer. He or she must be able to take charge, know what to do, when and how to do it, and to accomplish it all within a very limited amount of time. Everyone involved will expect this.

With this demand and pressure on you, it is essential that you know thoroughly the steps in altar-return photography and be prepared to take them briskly.

THE VALUE OF ALTAR RETURN PHOTOS

Before going into more detail on what is involved in shooting altar returns, let us explain the value of shooting at this specific time in the festivities.

Record of Environment—Most brides choose a wedding site because of its appearance or because of its religious significance. This environment becomes an integral part of the

wedding day and wedding story and it is clearly important to memorialize it on film. However, mere photographs of the ceremony site—the front of the church or temple, for example, or the altar alone—without the bride, the groom, members of their family, or members of the bridal party, are meaningless and generally will have little appeal. You must include people who have some significance for the bride, groom and their families.

Neatness of Attire—At most weddings, the bride, the groom, each member of their respective families, and all the members of the bridal party will dress up for the occasion. They will all look their best at the time the service takes place and immediately after, during the altar-return photography session. Consequently, you'll have the best chance for making fine pictures at this time.

When they get to the reception, people begin to relax and think less about their appearance. Ties get undone, collars get opened, clothing becomes staine
smeared. The
you is that yo
formal image
Subjects S
brides and gr
of certain

friends. Often, the wedding participants or their families will not have been together for years. The wedding will have been the catalyst for a reunion.

At the ceremony site, you'll have a captive group in that all of the important people to photograph will usually be there. Once the wedding service is over, one or more of these people may leave or otherwise become unavailable. For example, at the reception some may be dancing while others are at the bar or visiting guests at various tables. If the group is large—say 15 to 20 people—it may be difficult or impossible to get them together for photographs. You will thus have missed your opportunity to record pictorially a valuable facet of the bride's day. If a bride wishes a photograph of her entire family but her brother is absent, she'll refuse to have the picture taken or, if she does allow it to be taken, the chances of her buying it are slight.

Sobriety—At the ceremony site, generally all of the important people you will have to photograph will be sober and will look and feel their best. However, once at the reception, some may have a bit too much to drink and this can present a problem for you. Photographically they may no longer look their best and they may become difficult to work with. Even if you do secure their cooperation, the photographic results will often be poor.

Increased Sales—Not the least important consideration for a photographer who shoots weddings for a living is the sale of prints. The more time a bride allots you for altar-return photography, the more variety you can offer. Be assured that brides and grooms, and their families, buy such photos.

eparing for Work

d preparation is important for
ng photography, but es-

pecially for the altar-returns phase. Without it you throw the results of the session open to chance and subject your photographic credibility to doubt. To help you guard against this and to enable you to photograph an altar return successfully and quickly, we suggest your preparation include attention to the following:
1. Planning.
2. Time factor.
3. Role of assistant.
4. Presence of other photographers.

PLANNING

Of all the wedding phases, this one requires the most precise organization. Your "game plan" must allow you to work fast and efficiently. You must have definite images and poses in mind. You must also advise the bride and groom of your plan so they can arrange to have all of the important people stay behind, after the service is over. If you don't, some may leave and important images will be missed.

You also must know in advance who all of the people to be photographed are and what problems you might encounter when photographing certain people together.

For example, you may have a bride whose parents are divorced and desire not to be photographed together but do desire photographs of them with their new spouses. In such a case you will have to photograph the bride and groom with the bride's mother and her new husband, then retire them and photograph the bride and groom with the bride's father and his new wife.

TIME FACTOR

Once the wedding service is over, the bride and groom, the bridal party, and the family members will experience relief and a readiness to leave for the reception, to have fun and to be with their guests and friends. This means the photographer must be prepared to work efficiently, com-

petently and fast. Tell all those involved that you understand their eagerness to go to the reception but that you need their cooperation for a short time: Inform them that, if they cooperate, the photography session will be brief.

Before the subjects return to the altar for the photography, all of the equipment you intend to use must be in place and ready to go. Never make subjects wait. They will lose interest fast.

If the bride and groom intend to have a receiving line immediately after the service and recessional, take your shots of the receiving line as previously outlined. Following this, go to the altar and prepare and set up all of the needed equipment for the photography at that location. You'll have about 10 to 15 minutes for this preparation, depending on the number of guests in the receiving line.

However, if they have elected to forego a receiving line, once the recessional is over the bridal party and the family members will immediately return to the altar for the formal photographs. In that case, you must have your equipment ready before the service and recessional conclude, so that you need only set it up to meet specific requirements at the last minute. You'll have only about three or four minutes to set up your equipment before all of the group have reassembled at the altar.

As a general rule, you'll need from 30 to 60 minutes to complete the altar-return photography, depending upon the number of family members and of those in the bridal party, how cooperative they are, and the space in which you have to work. For example, a church or temple may be designed in a fashion not conducive to good group photography. You may find yourself having to move people, lights and other pieces of equipment each time the size of the group changes. This can put a great dent into

your allotted time.

Special Limits—There are two other potential time limits to consider: The mandates of those officiating at the ceremony site and of the bride and her family.

At the time the bride books her wedding with you, you must tell her the approximate time you will need for altar-return photography and then find out how much time she intends to allow you. Often brides have no idea of what is involved, the significance of this phase, or the time needed to accomplish it.

No matter what the wishes of the bride may be concerning time for photography before, during or after her wedding service, if the wedding official at the church or temple decides otherwise, you must abide by his ruling. Just be sure you so inform the person who hired you, usually the bride.

Although a bride may initially be very generous about the time she allots for the altar return, be prepared for her to change her mind on the day of the wedding. There have been many instances when we thought we had 60 minutes in which to do the altar return, only to find out on the wedding day that we had been cut back to 10.

ROLE OF ASSISTANT

Many of you will be doing your first several weddings unassisted. However, as your needs grow and you take on a helper or two, keep in mind that the main role of the assistant is to assist. That may sound obvious. What we mean is that the *prime* job of the assistant is not to take photographs. The assistant's main function is to help carry, manage and watch over all of your equipment.

The assistant should also help with the posing and in getting people together for selected images. He should also load and unload your film, make sure your cameras are al-ways ready, change lenses, and watch your off-camera flashes to see that they have fired.

Before you take any assistant on a wedding assignment, make sure you have trained him thoroughly. He should know exactly what you expect from him and how you expect him to do it. The site of an actual wedding should not be a training ground.

PRESENCE OF OTHER PHOTOGRAPHERS

At most weddings, during all their phases, you will find friends, relatives and guests of the bride and groom taking photographs. Often, they will be photographing the same views you have posed and arranged. They will slow you down, get in your way, and increase the time you need for your photography. Sometimes they will even affect the quality of your images. Of course, their shooting may also affect your sale of prints. After all, yours will have to be paid for while theirs will usually be free.

In spite of these possible difficulties, never become involved in any altercation with these other photographers. Attempt to have the bride restrain them from photographing until you have finished. If that fails, try yourself, tactfully, to persuade them to wait. If that also fails, do your photography in spite of them.

Lighting

Most of your altar-return photographs should be taken with flash. Although you could do the entire session of a small wedding with just your on-camera flash, the results will be much better if you use dimensional lighting, such as on-camera and off-camera flash with ambient light as a fill, or an off-camera flash as the main source with an on-camera flash as a fill.

In addition, for added variety, take a few photographs illuminated only by natural light, especially views of the bridal couple and of the entire wedding party.

LIGHT CONTROL

More altar-return photography has been ruined by improper light control than you could possibly imagine. The most common reason for this is lack of experience and knowledge on the part of the photographer and the fact that most portable flash units do not have modeling lights. Without modeling lights—tungsten lights built into flash units to enable one to see where the flash will strike the subject—the photographer cannot see exactly where the light will fall and cannot predict the result.

The condition worsens when off-camera lights are handheld by an assistant. When you put an off-camera light on a stand, you know the general direction the light is going to travel. Unless someone trips over the light stand, the height, angle and distance of the light from the subject will not vary. But if you place that light into the hands of your assistant and take your eyes off him to make your photograph, you will not know whether the light was moved until you see the processed pictures—and then it will be too late!

Handholding a second, off-camera flash may be all right for a few head-and-shoulder photographs, but when you are engaged in 30 to 60 minutes of altar-return photography it is just too risky. The chances of getting bad light placement, and therefore bad lighting on the subjects, are so great as to far outweigh the slight inconvenience of putting the light onto a stand.

Keep your lighting simple. For the most part, group altar-return photography requires documentary, non-complex lighting and light placement. You'll generally have neither the time nor the space to be sophisticated with the lighting.

LIGHT PLACEMENT

Your basic lighting technique and light placement should be the same, whether you happen to be using studio or portable lighting equipment. Your major concern is to position your lights so that all of the subjects receive even illumination. You want light on every face, without the shadow from one person falling onto the face of another.

Follow these basic guidelines:

• If you want to see something, light it. If you don't, don't.

• For all of your off-camera lights, the midpoint of each flash should be at the height of the subject's face and angled slightly downward.

• For lighting individuals or couples, use one on-camera flash only or use two lights—an off-camera flash as main light and the on-camera flash as fill light. Place the off-camera light about 45° to the right or left of the camera-subject axis (Sketch 6-A).

6-A

• For groups of four or more people, use three flash units—one on-camera and two off-camera. Adjust all three to emit the same quantity of light. Place one off-camera flash to the right of the camera-subject axis and one to the left, at the same distance from the camera. The one on the left should be directed at the midpoint of the people standing to the right of the bride and groom. The flash to the right of the camera should directed at the midpoint of the people standing to the left of the bride and groom. The on-camera flash should be directed at the bride and groom (Sketch 6-B).

This will give you a bank of light for all the subjects, with even illumination.

6-B

• As the group of people to be photographed becomes larger, you'll need to become more critical about the placement of your lights and their direction. The lights should be closer to the camera-subject axis. When photographing one or two people, you can afford to have your off-camera flash as much as 45° to the right or left of the camera-subject axis, pointing the light inward toward the camera-subject axis. With a group of 10 or more people, the off-camera flashes should be within 10 to 20 degrees of the camera-subject axis and angled away from that axis (Sketch 6-C) to ensure even illumination.

6-C

It's helpful to think of a large group as several smaller groups combined. For example, Sketch 6-C shows 10 people. There are actually three small groups—the bride and groom, the four people to their right, and the four people to their left. Each group is lit separately although, of course, there is also some light overlap.

Because all three flash units are of

the same size and light output, the group will be lit very uniformly.

MORE ABOUT GROUP LIGHTING

A discussion of the lighting for two standard poses of groups will clarify the principles involved in group lighting. The first pose, which we've just looked at (Sketch 6-C), we call the upside-down V pose. The second we call the split-T (Sketch 6-E).

Upside-Down V Pose—This is a traditional pose. Most wedding albums include a photograph or two with this composition or a slight variation of it. Although it is simple to set up (Sketch 6-C), many photographers do not use the proper lighting for this configuration.

There is a variation to this three-light placement using the same upside-down V pose (Sketch 6-D). It produces a photograph a bit more dramatic, but requires more space than the arrangement just described. This arrangement contradicts a general rule that you should not crisscross your lights. However, it's OK to do so as long as you don't create conflicting shadows.

6-D

The slaved lights to the right and left of the camera must be directed inward, toward the center of the group of people on the opposite side of the lens-subject axis.

Your on-camera light, as before, will illuminate mainly the bride and

groom. Just as before, all three flash units should be adjusted to emit the same amount of light. And, as before, there will be a certain amount of overlap of the light from the three sources.

6-E

Split-T Pose—For this arrangement (Sketch 6-E), the light placement is similar to that for 6-D. The light to the right of the camera illuminates the bride and groom; the light to the left of the camera illuminates the group to the right of the camera. The light output of the on-camera flash can be adjusted to act either as third main light or as fill light for the other two.

Checklist for the Altar Photos

There will be instances when you will be extremely pressed for time and unable to photograph everything you would like for this phase of the wedding. You will be forced to make some choices. The following lists are designed to help you make wise choices.

ESSENTIAL PHOTOGRAPHS

We would suggest there are at least five images you should not omit:
1. Bride by herself.
2. Bride and groom.
3. Bride and groom with bride's parents.
4. Bride and groom with groom's parents.
5. Bride, groom and the entire bridal party in an upside-down V pose.

These five situations constitute the bare minimum for altar-return photography and will take you about five to 10 minutes to accomplish.

DESIRABLE PHOTOGRAPHS

As your allotted time increases, so should the number and variety of photographs you take. When possible, we suggest you take the following additional photos:
6. Bride, groom and their parents.
7. Bride, groom, bride's parents and bride's brothers and sisters.
8. Bride, groom, bride's parents and her grandparents, and brothers and sisters with their spouses and children.
9. Bride, groom, groom's parents and groom's brothers and sisters.
10. Bride, groom, groom's parents and his grandparents, and brothers and sisters with their respective spouses and children.
11. Bride, groom and bride's grandparents.
12. Bride, groom and groom's grandparents.
13. Groom by himself.
14. Groom with best man.
15. Groom, best man and ushers.

16. Groom with brothers.
17. Groom with brothers and sisters.
18. Bride with sisters.
19. Bride with brothers and sisters.
20. Bride with maid of honor.
21. Bride, groom, maid of honor and best man.
22. Bride, maid of honor and bridesmaids.
23. Groom, maid of honor and bridesmaids.
24. Bride, best man and ushers.
25. Bride, groom and entire bridal party in split-T pose or variation.

It is natural for the bride and her family to be concerned about the amount of time they are spending at the ceremony site for formal photos. They are anxious to leave and play host and attend to their guests at the reception. This anxiety can cause you extra pressure and endanger your allotted time for altar-return photography. We deal with this situation by making first all photos involving the parents of the bride. When they are able to leave for the reception, a lot of pressure is taken off the bridal couple. They feel less pressed to leave at once for the reception and will give you more time for your photography.

As you finish photographing each person, couple and group at the altar, let them leave. Eventually, the only persons left will be the bride and groom, making it easier for you to move photographically into the next wedding phase.

If you miss some of the additional altar-return photographs, don't panic. You will be able to do similar ones later, possibly at the reception.

Photos in This Chapter

All of the photographs in this chapter were taken with the following equipment and at the following exposure settings, unless otherwise noted: Hasselblad camera; 60mm wide-angle lens; three portable flash units, one on-camera and two off-camera and slaved; exposure, f-8 at 1/60th second; metering by Minolta Auto 3F meter in incident-light mode for ambient light.

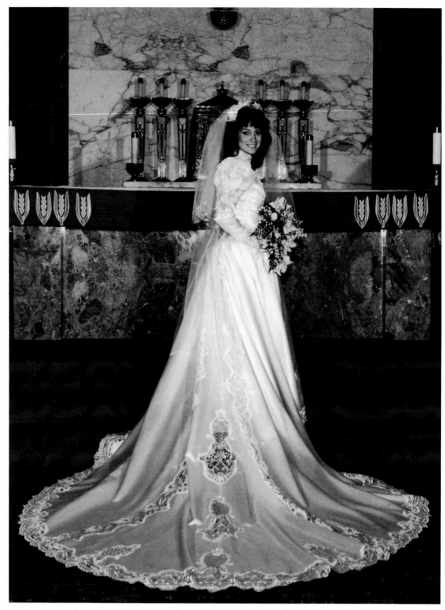

When doing altar photographs such as this one, the bride's train must be placed in front of her or to one side and never behind her. It must not be concealed. This image was illuminated with two flash units, one on-camera and one off-camera and slaved. Both flash units were adjusted to emit the same amount of light. Detail in both the bride's dress and the background is discernible.

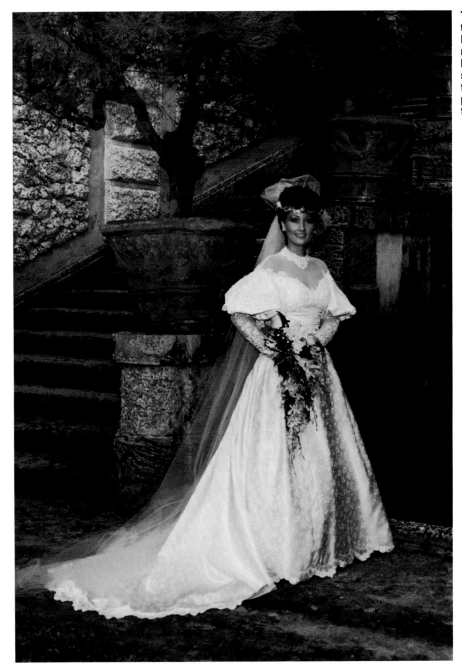

This bride had her wedding outdoors and the entire area became one huge altar. For this photograph the bride was illuminated with a single, on-camera flash with balanced ambient light. The view of the surrounding area cannot help but recapture for her the wedding ceremony. Such photographs are beautiful contributions to any wedding album.

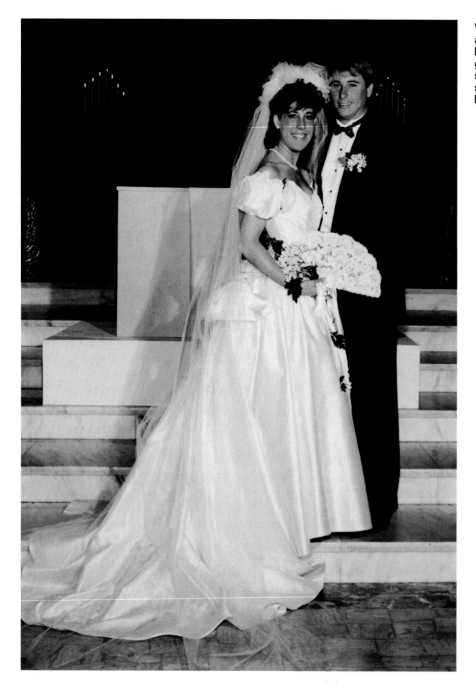

When doing altar photographs of the bridal couple it is essential to include a full-length view that shows the bride's entire gown and veil. This was a two-light setup—one flash off-camera as the main source and one flash on-camera as a fill light.

This is a grouping of close family members: the bride, the groom, her father, and her sisters with their spouses. The pose is called a line pose. All the subjects are in the same plane. The background was intentionally allowed to go dark so as not to compete with the subjects.

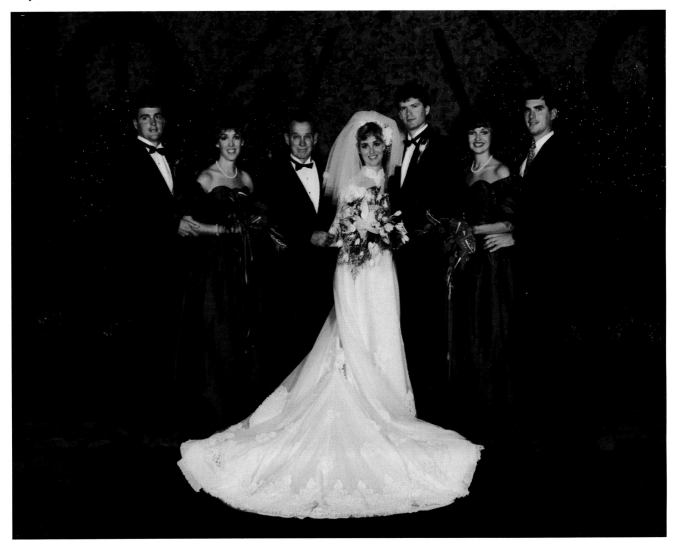

This casual pose of the bride, the groom and the entire family is termed the scattered pose and works well when small children are involved. It is especially useful when you are working in a confined area. It also gives the image an air of togetherness.

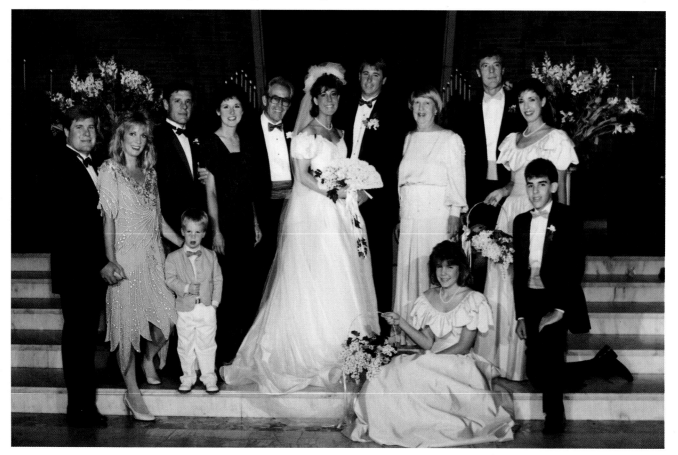

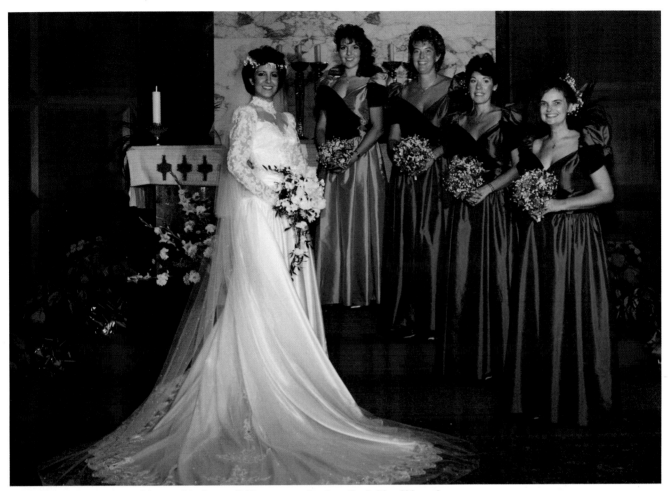

This image of a bride and all her maids, in a split-T pose, emphasizes the bride. Although the pose is not a traditional one, it's eye-catching and a winner for any bridal album. It was illuminated with two flash units, one on-camera and one off-camera and slaved. Both units were adjusted to emit the same amount of light.

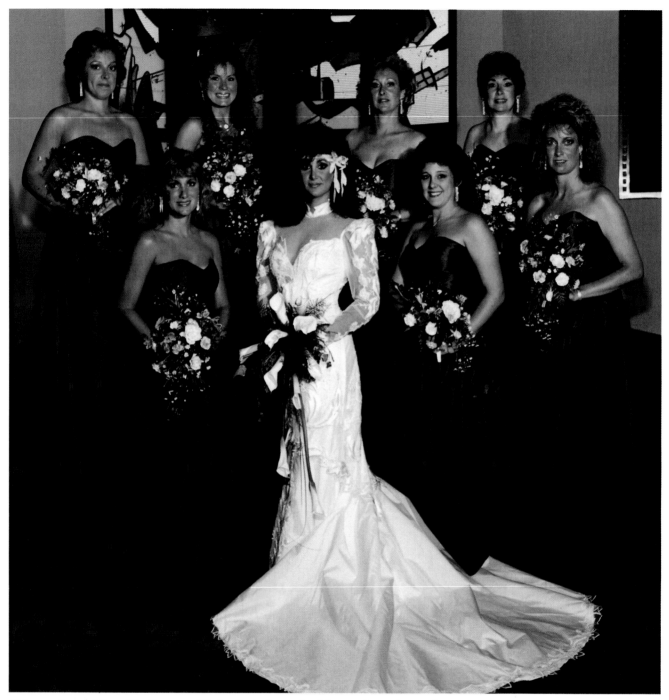

This pose is a variation of the line pose. Placing the last row of maids on a step makes each face more visible than would be possible if they merely stood directly behind the front row of attendants. The bride, by wearing white and being in the center, retains her pictorial prominence.

This is a typical, traditional, upside-down V pose (see Sketches 6-C and 6-D). Every face is illuminated and easily seen. Every altar-return session should include such a pose. Once you have so photographed the groom with his ushers, photograph the bride with all of her maids in the same pose. Brides, grooms and their families expect to see such images and will buy them.

Unlike the traditional pose in the previous photo, this photo is in the contemporary style. It's more relaxed and casual, with a sense of flow. It offers a bride and groom pictorial variety.

Here's another example of the traditional upside-down V pose. A variation is possible by placing two couples on either side of the bride and groom, rather than placing the ushers on one side and the bridal attendants on the other, as we have done here. Either version is acceptable.

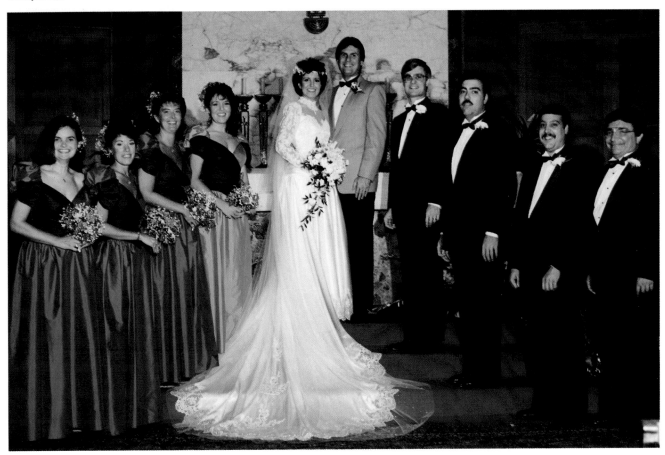

A contemporary look is achieved with the split-T pose (see Sketch 6-E). Placing the bridal couple to one side increases their prominence.

As in the preceding example, the split-T pose was used. However, this time all eyes of the bridal party were focused on the bridal couple as they kissed. Both kinds of images make great bridal album contributions.

When you have a bridal party as large as this one and space is limited, arranging the group carefully in couples will allow all the faces to be seen. Moving the bridal couple slightly forward will preserve their prominence. With a group this size, it is essential you enlist full cooperation. Because of its general shape, we call this the horseshoe pose.

Angie & Stacey on stairs in front of church

attendants on porch

This bride and groom were married in a small chapel that did not lend itself well to photography of even their small bridal party. Accordingly, they were taken out into the courtyard of the church for the altar-return images. The pose is a modified split-T pose. A single on-camera flash was used to illuminate the bridal couple, balancing it with daylight for illuminating the bridal party.

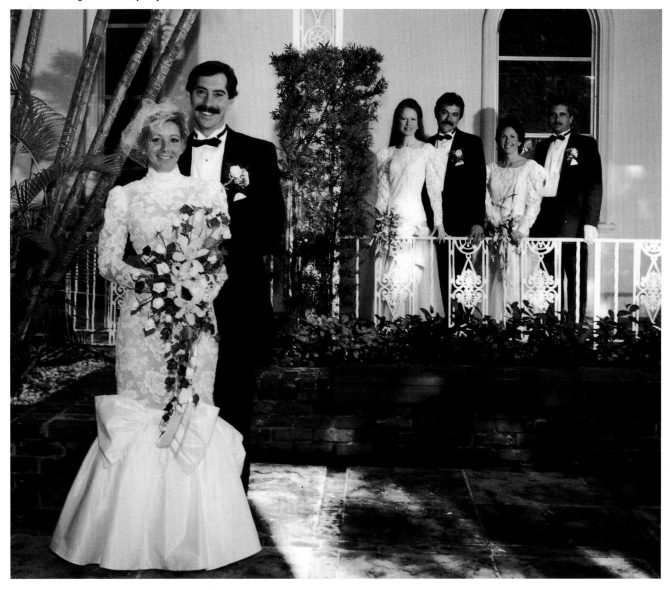

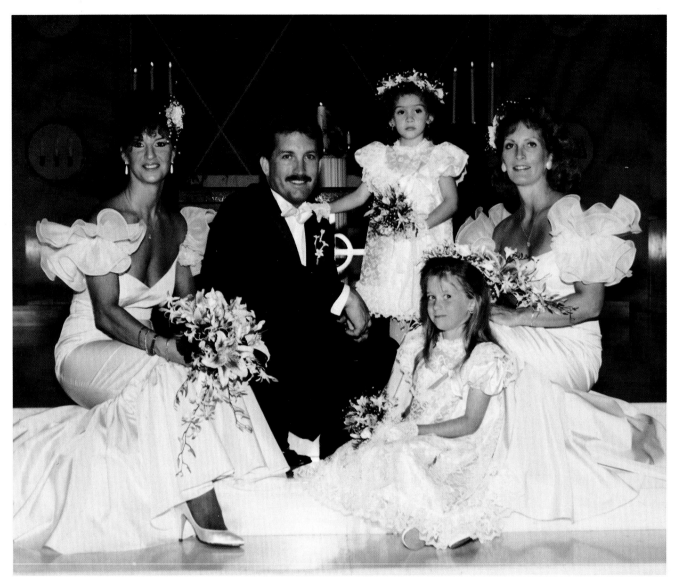

Images such as this one, in which the groom is seated and surrounded by all of the bridesmaids, are fun and help offset the formality of altar-return photographs. They can be executed with a single on-camera flash or with a three-light setup. Don't forget to lower your lights to the height of the subjects. The reverse pose, with the bride seated and surrounded by all of the ushers, is also a winner.

Before you take a photograph such as this one, instruct the maids to give the groom a hug or a kiss. While they are trying to do so, take the photograph. Then remove the groom and all of the girls, seat the bride, surrounding her with the ushers, and have them kiss or hug her. Both images are winners.

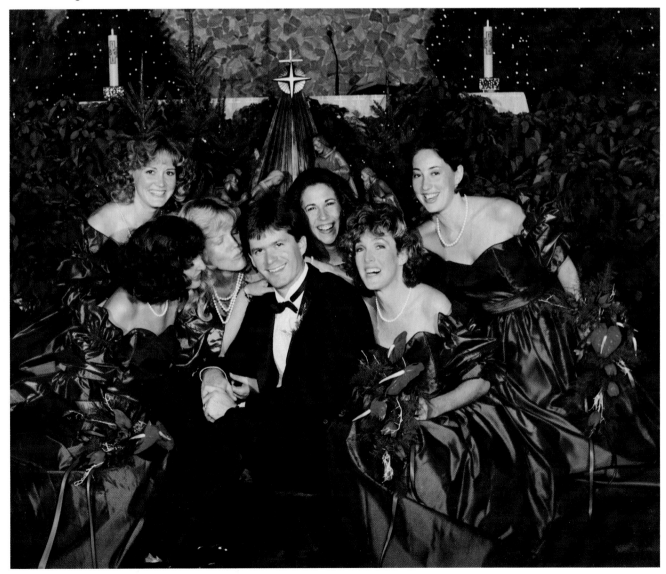

On Leaving The Ceremony

This stage of the wedding photography actually involves two of the phases listed in Chapter 1—the exit phase, or the departure from the ceremony site, and the phase of making romantic environmental shots, either outside the church or temple or at a suitable location on the way to the reception. This part of the job is not especially complicated, the equipment required is minimal, and the interaction of only two people—the bride and the groom—is involved. Photographs taken during these phases help round out a bride's album while adding an element of warmth, romance and sometimes humor.

Up to this point of the wedding day, all of the photographs of the bride and groom, with the exception of a few formal altar-return images, have been of them individually or with family and friends. Now, during the romantic phase and sometimes during the exit phase, you have an opportunity to photograph them together as man and wife.

Sequence of Events

The sequence of photographic events for both the exit and romantic phases are generally as follows:

1. Some romance photographs will be taken after all of the formal photographs at the altar have been concluded.
2. Photographs, after the first romantic ones, of the couple leaving the ceremony site for their limousine and the reception.
3. Additional romantic photographs en route to the reception area.
4. More romantic images periodically throughout the reception, both in and out of doors.
5. Photographs of the bridal couple leaving the reception area for their honeymoon.

However, since all weddings are not the same, you'll not only find the order of the exit and romantic phases varying but you'll also find a variation within the exit phase itself.

Most weddings will have two exit scenes. The first will generally occur after all of the photography at the ceremony site has been completed and the bridal couple prepare to leave for the reception. The second will occur at the end of the reception as the bridal couple prepare to leave for their honeymoon. This second exit is discussed in Chapter 8.

There will be weddings, however, at which there will only be one exit scene, when the ceremony and the reception are held at the same place. It will occur at the end of the reception. In a few cases, there may not be an exit phase at all. This generally happens when the ceremony and reception are held at the same place, such as at a hotel, and the bridal couple stay overnight at the conclusion of the reception.

When no exit phase is scheduled, the experienced wedding photographer will create one and record it on film. This, too, will be discussed in Chapter 8.

When the wedding has two exit scenes, the first can come about in

two ways: You may find it advisable to take some romantic photographs immediately after the altar-return phase and then the photographs of the exit or it may be necessary to reverse that sequence. That is, while all of the guests and important people whom you have photographed during the altar-return phase are still present, the bridal couple will fake an exit. They will leave the building, undergo a rice-throwing, enter their bridal limousine, sip some champagne from inside the car and even drive off—but only around the block. On their return, they will go back inside the building for the first round of romantic photographs.

It really doesn't matter which sequence is followed as long as you capture as much pictorial variety as possible.

Photographing Romance

The romantic photographs should be taken a few at a time throughout the wedding day. Some should be taken inside and outside the ceremony site after the altar-return phase, additional ones at a pre-arranged scenic spot enroute to the reception site, and still others at the reception itself, both indoors and outdoors.

It is possible to take all of the romantic photographs at one time and in one place. However, the album would then contain much less pictorial variety and picture sales would suffer. Spacing such photography over several hours and with varied backgrounds also helps keep the couple from tiring and becoming bored.

When we take romantic photographs we make each session brief—usually no longer than five to 10 minutes. Consequently, the bridal couple don't feel as though they are neglecting their friends, family and guests by their absence.

From a business viewpoint, to take three photographs of the bride and

groom kissing at the altar will probably result in their buying only one of the images. However, to take three photographs of them kissing at different places—the altar, beside a waterfall and at the reception, with their wine glasses in their hands—could well mean selling all three images.

WHAT'S DIFFERENT HERE?

In Chapter 3, when we discussed doing formal photographs of the bride, we also discussed romantic photographs of the bride and groom in the studio and on location. Those differ from the ones presently under discussion.

In the first situation, a large block of time is spent with the couple, usually an hour or two. You are in a controlled environment—a studio or outdoor place of your choice. You can use or transport any equipment required. The couple is usually dressed casually and the atmosphere is relaxed.

When romance photographs are taken on the wedding day, things are very different. You are working in environments almost totally selected by the bride. You are working fast and with limited equipment. The couple's attire is usually formal.

Because the only common thread between the two situations is the bridal couple, the photographic images of these two people will be different. In the earlier casual-couple session, the emphasis is on the couple and the environment is only a supporting element. Although after the ceremony the emphasis is still on the couple, the environment assumes a greater role.

For example, when romantic photographs are taken in and outside the church where the couple are married and in and outside the reception site, the location has a personal meaning and importance to the couple. More of these images are likely to be sold than of those from the casual session of the couple.

CAPTURING EMOTION

Don't rush things during the romantic phase of your photography. Don't disturb the "moment" or the feeling that the couple now have for each other. If you scurry about, they are likely to sense this, change their mood and frustrate the effects you are after.

The first segment of the romantic phase, after the wedding ceremony is over, is an ideal "down time" for the couple, a chance for them to relax and be themselves. Often all of the guests, family and friends will have departed for the reception, affording you the undivided attention of the bridal couple. This will make it easier for the couple to slip into the tender, personal and loving mood you seek from them.

The bridal couple will have just spent the preceding hour being told by a wedding official that their past, as individuals, is over and that they are one entity and united, that they are married forever.

Capture that unique moment in their lives with sensitivity, looking for interactions that are quiet yet thought-provoking, that reflect love and tenderness. Photograph emotions, not just people.

If the bridal couple are not demonstrative before your camera, you must take charge and structure the photographs. This means that you must have definite images in mind and know how to arrange them. The couple will depend on you for guidance.

EVERY IMAGE COUNTS

All of the romantic photographs you take will be important. They will add an emotional element to a bridal album that documentary images may lack. They will have the basic components of pose, lighting and location, but they will also have the reflection of love in the facial expressions and body language of the bridal couple.

Take some head-and-shoulder, three-quarter-length and full-length photographs. Include an image or two of the environment as the primary element, with the bridal couple as a secondary one.

EQUIPMENT NEEDED

Since you will not spend much time with the bridal couple during any one romance photography session, don't overload yourself with equipment. All you will need are a camera, a standard and a slightly wide-angle lens, a tripod, a cable release, an incident-light exposure meter, one on-camera flash, one off-camera flash that is slaved and on a light stand, and a soft-focus or diffusion filter.

Photographing the Exits

Whether the exit of the couple from the ceremony or reception site is faked or is an actual departure, the wedding photographer must be assertive in directing the couple in order to record it well.

WHAT TO PHOTOGRAPH

The photographer must be aware that it will take the bridal couple only about three to five minutes to walk out the front door, get into their limousine and drive away. That isn't enough time for an involved series of photographs. They must be well planned and simply structured. There will be no time for "frosting" photographs.

Some of the photographs taken at the exit phase may have a romantic quality but, essentially, they remain exit photographs if they show the bridal couple in front of the ceremony site or by the bridal conveyance, be it a stretch limousine, horse and buggy, yacht or something else.

We suggest the following must-get shots:

1. The bridal couple standing in front of the ceremony site.
2. The bride about to enter the bridal limousine, receiving assistance from the groom.
3. The couple inside the limousine, photographed from outside.
4. The couple inside the limousine and sipping champagne, shot from inside the car.
5. The couple inside the limousine and toasting each other, from inside the car.
6. The couple inside the limousine, with the wine glasses in their hands and kissing, from inside the car.

If you do have the opportunity to improvise a variation of one of these, do it, but be mindful of the time factor. It could cost you time allotted for romantic photographs.

EQUIPMENT NEEDED

Because the time available for this phase is so limited, it's advisable to limit equipment to camera and attached flash. A wide-angle lens will ensure adequate inclusion of the environment.

Photos in This Chapter

Unless otherwise indicated, all of the photos contained in this chapter were taken with the following equipment and at the following exposures: Hasselblad camera; standard or slightly wide-angle lens; one portable on-camera flash and one off-camera flash on a light stand and slaved; Minolta Auto 3F meter, used in incident-light mode.

When only the on-camera flash was used, it was adjusted to emit light for an f-11 exposure. When both the on-camera and off-camera flashes were used, the off-camera unit was adjusted to give two f-stops more light to the subject than the on-camera unit. Camera exposure was set halfway between these two extremes.

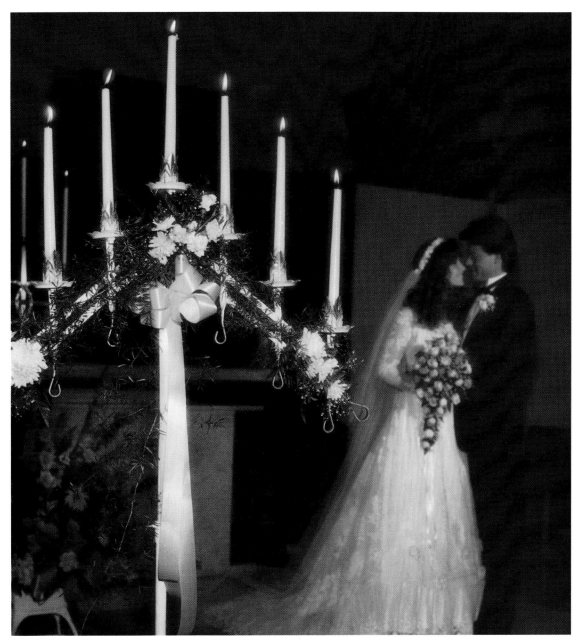

This is an extremely simple image to execute and one that sells well. The point of focus should be on the flower arrangement, which should be illuminated with your on-camera flash. The bridal couple should be placed beyond the depth of field, to render them slightly "soft." The couple should be illuminated with an off-camera flash, adjusted to emit one full *f*-stop less light than the on-camera flash.

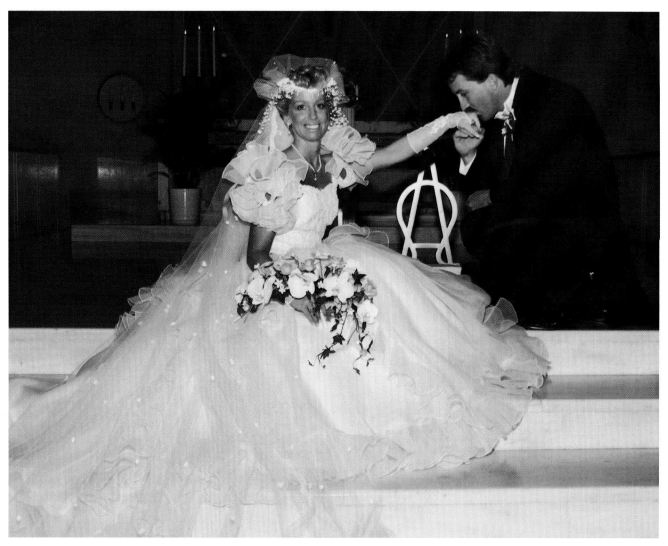

This view is one of four, done without the bride or groom changing positions. The first image should be of the couple looking at each other, the groom holding her hand. The second should be of him kissing her hand while she looks at him. The third view is shown here. The fourth should be of the groom holding his bride's hand as both turn to face the camera. Of the four shots, usually two are selected. The photo reproduced here was executed with a single on-camera flash.

This is a variation of the previous photo. Notice how the effect has been changed by changing the lighting. The on-camera flash was used as a fill light and a main light was placed approximately 110 degrees to the right of the camera-subject axis.

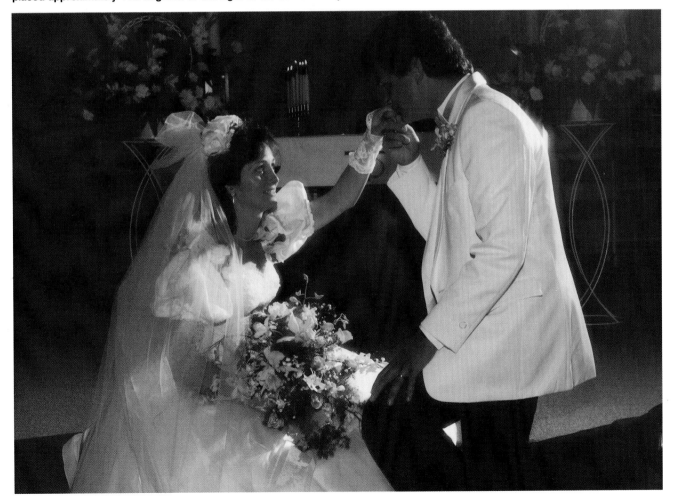

This photograph was made mainly by available light. A remote flash was placed behind the bride to accent the bridal veil and draw the viewer's attention to the center of the image. The color negative film was exposed at one full *f*-stop more than the incident-light meter indicated.

Because this image was made on VPS III daylight film and the illumination inside the church was tungsten light, the film took on an orange color bias, adding warmth and a feeling of togetherness to the scene. Had tungsten-balanced film been used, the image would have appeared too literal, too realistic.

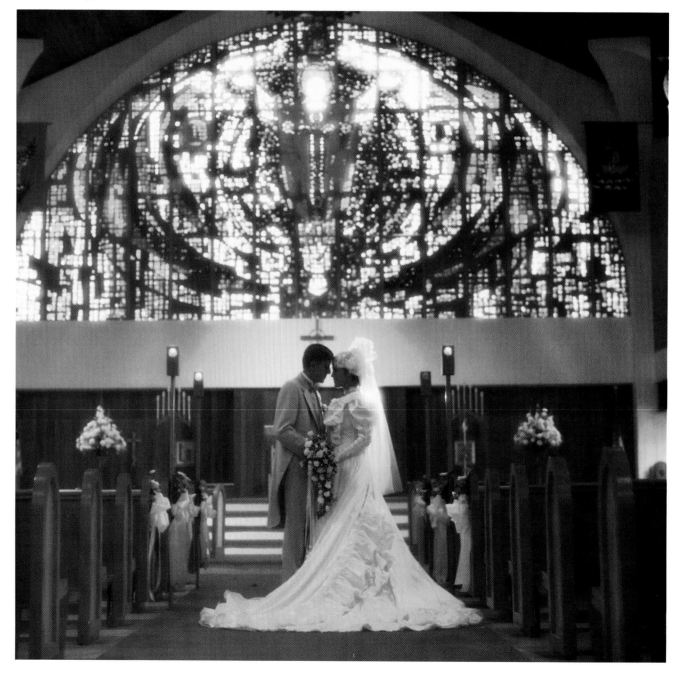

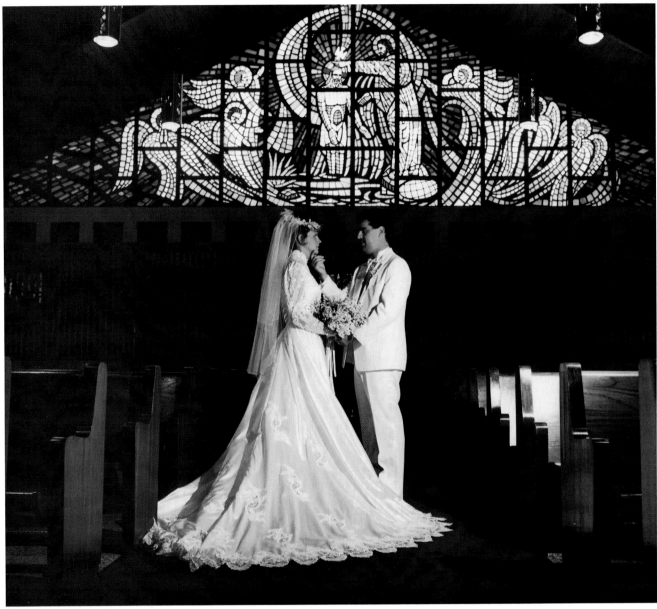

In contrast to the photo opposite, ambient light was not allowed to dominate this scene. The couple were illuminated with a single off-camera flash. A meter reading was taken of the light from the stained glass window and the shutter speed adjusted to give one full *f*-stop less exposure than the meter indicated.

This is another variation of the previous two photos. For this image, the available light was used to render most of the church visible. One off-camera flash was placed behind the bride to separate her from the background and make her appear illuminated by light from the rear of the church. The on-camera flash was adjusted to provide additional fill light.

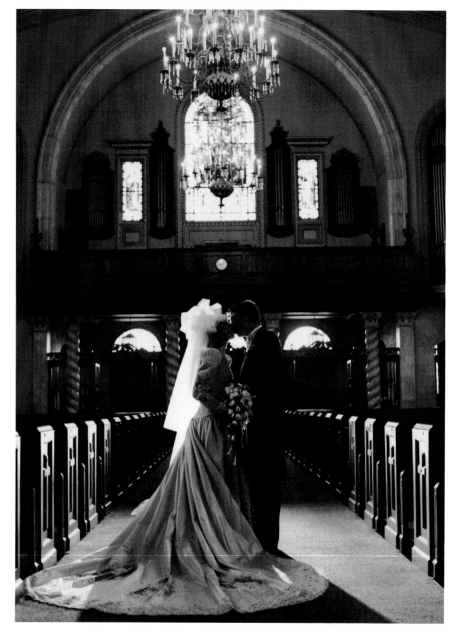

In this photograph, the name of the ceremony place was unimportant. The opulence and symmetry of the facade was a sufficient reminder for this couple. The image was made solely by natural light.

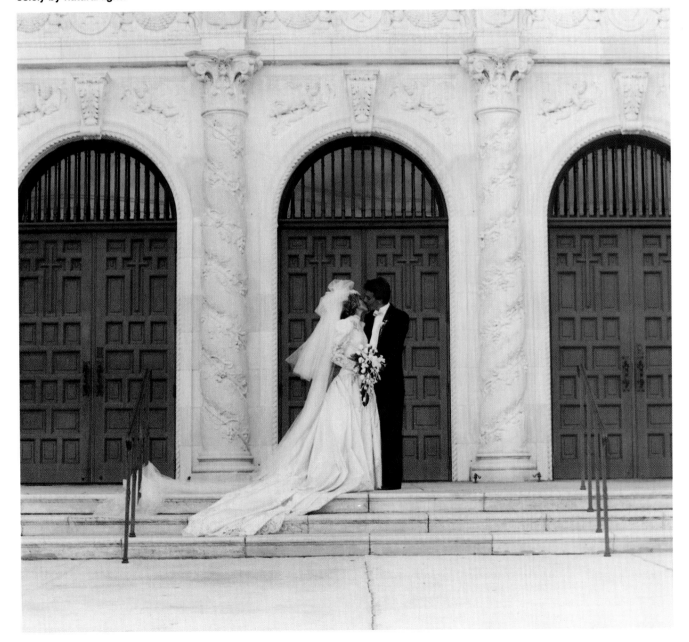

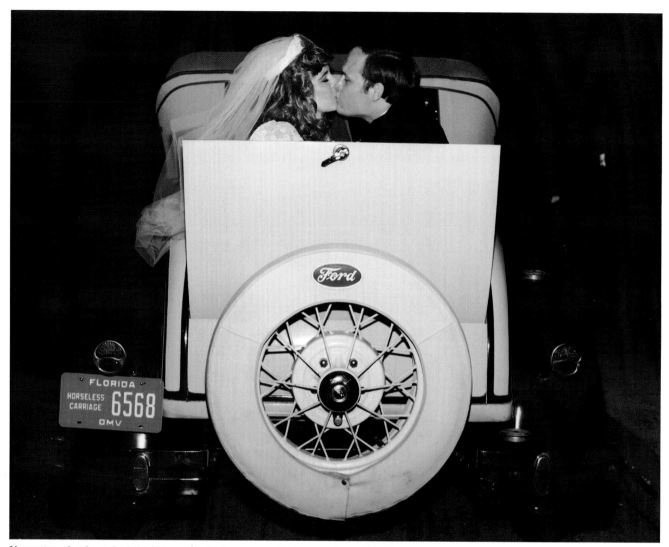

No matter what form the bridal "limousine" takes, record it for posterity on film. This couple were obviously proud of their carriage and thought it an important part of their wedding day. The photograph was made with a single on-camera flash.

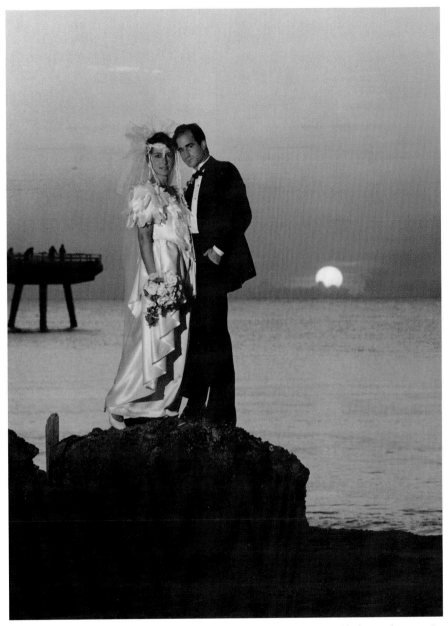

Never hesitate to take the bridal couple outdoors for views of them with the environment. You can sometimes do this on the way to the reception and at other times at the reception. Such images can make stunning additions to any bridal album. The daylight and one off-camera flash were carefully balanced to achieve this striking image.

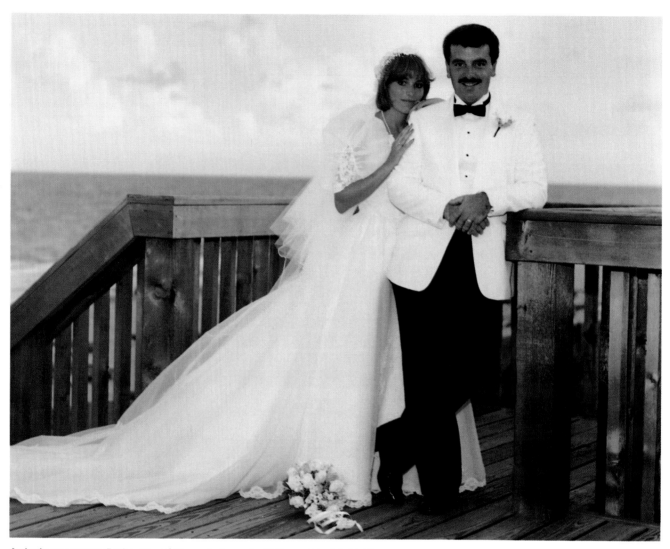

A single on-camera flash was used here, balanced with the ambient light. The groom was placed in a relaxed pose first, then the bride was positioned. As a general rule, whenever you are posing more than one person, start with one, get his or her pose established and to your satisfaction, then build the other pose or poses around it. The pose by this couple, which reflects their love and togetherness, appears natural, even though it was totally staged.

Be alert for any props that may help frame the subjects. However, use such devices with care. This photograph was made with a single on-camera flash, balanced with the ambient daylight.

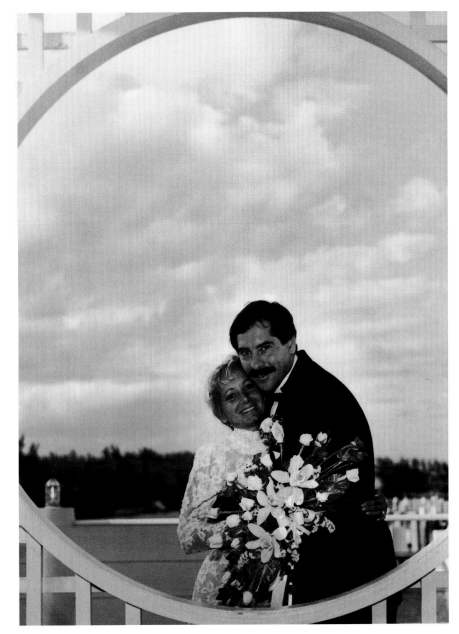

During any photographic phase, but especially when making romantic photographs, watch for any special attitudes or expressions from your subjects. You can often capture a truly unique image when you least expect it. In this case, we were between poses when the bride decided to demonstrate the fun she was having posing for the camera. A single on-camera flash was used.

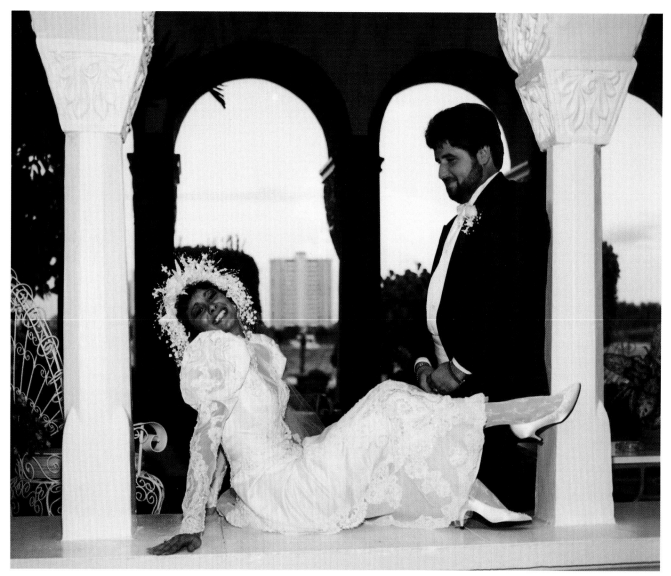

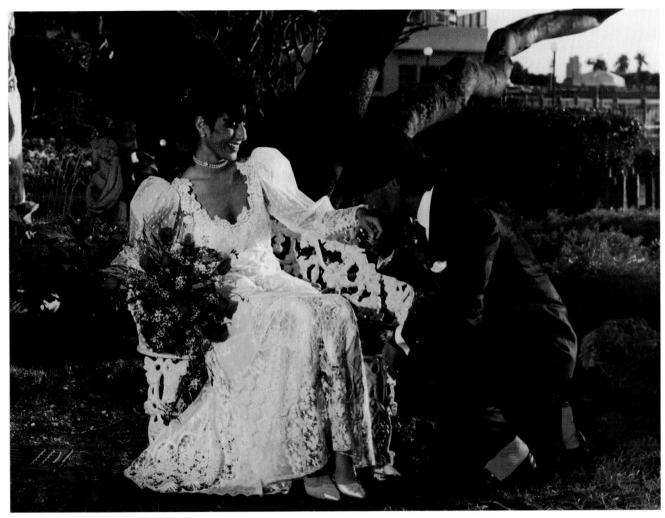

This couple's entire wedding was held in the garden of a restaurant during the late afternoon. The primary light source was the sun, which was side-lighting the subjects from the right side. A single on-camera flash, adjusted to emit one full *f*-stop less light than the daylight, produced the fill light.

During the reception, this couple was led outside to take advantage of the setting sun and the surroundings. The position of the sun was critical. The image would have had a different feel had the sun been concealed by the couple's bodies. Allowing the sun to peek through the opening between their bodies and strike the lens produced a slight flare and a soft, dream-like image. The shutter speed was set for one *f*-stop of underexposure of the ambient-light scene. The additional light of a single on-camera flash was also used.

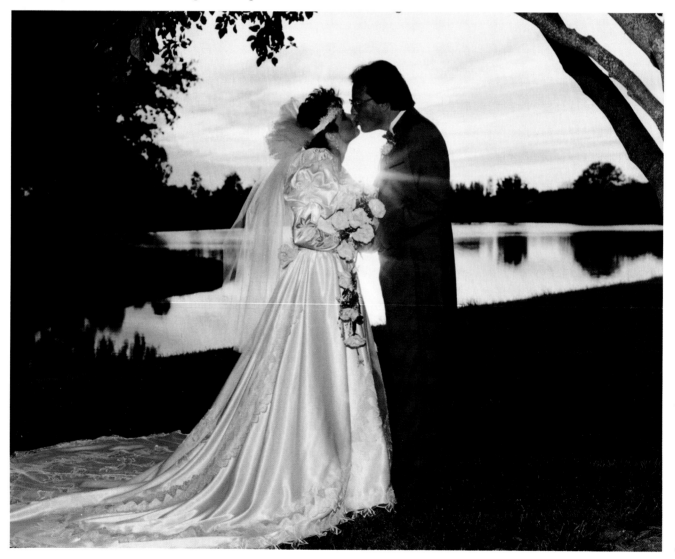

This shot of the bride and groom was done solely by available light. Compositionally, the placement of the bridal gown and veil were important. The gown added strength to the base of the photo while the veil's oblique flow introduced motion to an otherwise static scene.

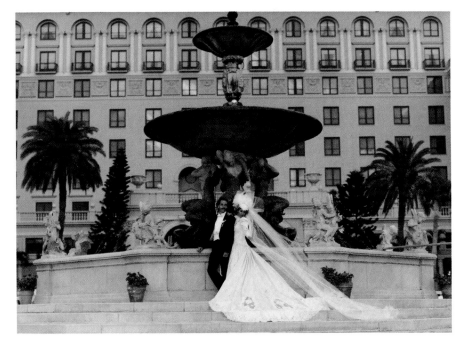

Events such as this cannot be staged, at least by non-professional models. These things happen spontaneously and you must be alert if you are to capture them. We were between poses, preparing for the next shot, when the groom became playful. Incidents such as this break the tension of the day, and photographs of them add greatly to a bride's album. The photo was made with a single on-camera flash, the ambient light being used as fill light.

115

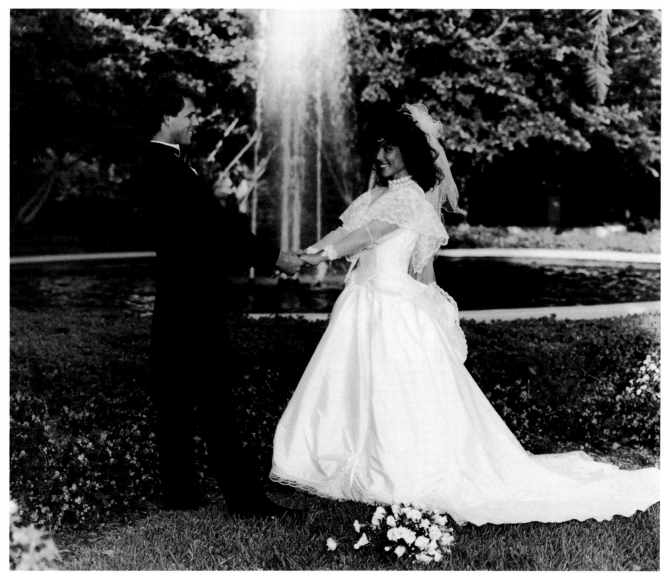

One of the reasons this couple chose this particular reception site was because they liked the garden area. A photographer would be remiss if he didn't photograph the couple involved with such an important place. The image was made using a single on-camera flash. The ambient light was used as fill light.

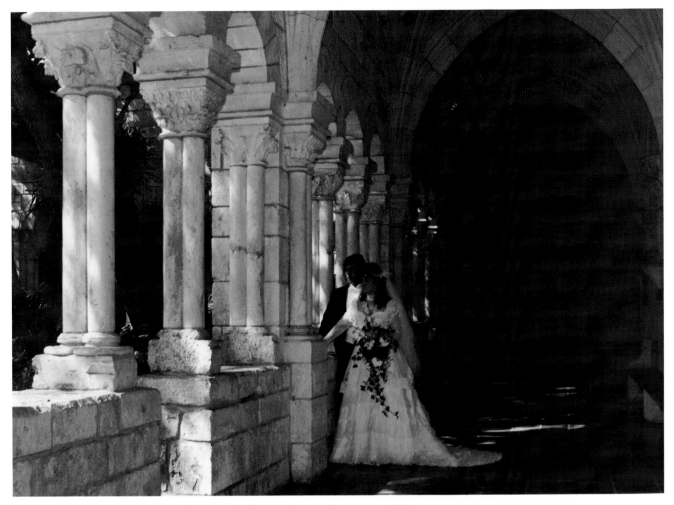

Include in your romance photographs as much of the environment as you can. This image, made using only available light, cannot help but remind the couple of where they were married and their feelings of love and togetherness. The photo was made with a wide-angle lens.

Although this image could have been im-
proved by the use of a two-flash set-up—
one off-camera and to the left of the
camera-subject axis as the main source
and one on-camera to act as the fill—the
spontaneous attitude of the couple would
have been jeopardized and a less desir-
able pose might well have resulted.

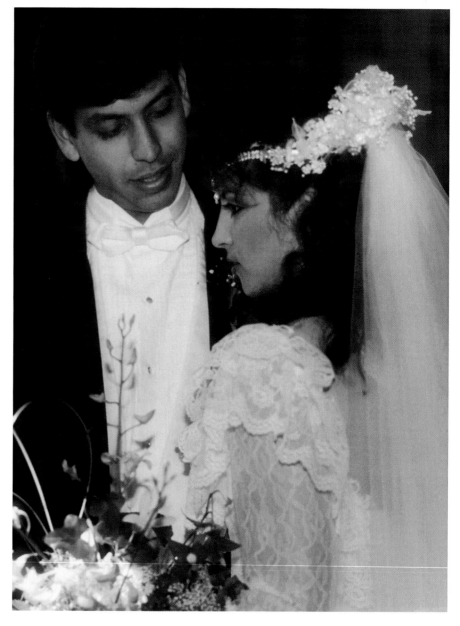

This photograph was taken in front of a waterfall near the reception site. Although the scene was recorded in daylight, it was handled in two different ways: One photograph was taken to show the background area prominently. The second photograph is shown here. Although you should generally show as much of the environment as possible, this image proved to be the more dramatic one of these two. One off-camera flash was used as the main light source. The shutter speed was adjusted to underexpose the ambient light by four full *f*-stops.

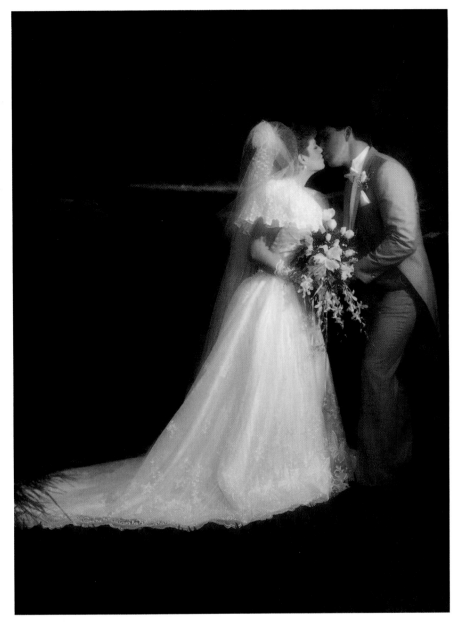

It was dark when we led this couple outside from their reception area for this special image. The only way we were able to focus was with the aid of a flashlight, directed on the white shirt and lapel area of the groom. Since there was no wind at all, we created our own motion. We had an assistant hold the bride's veil away from her body and at a signal the assistant let go and the photograph was taken. A single on-camera flash was used.

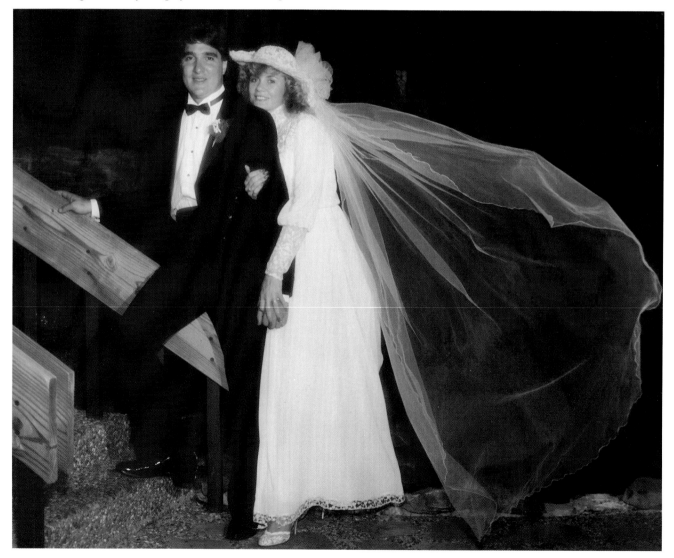

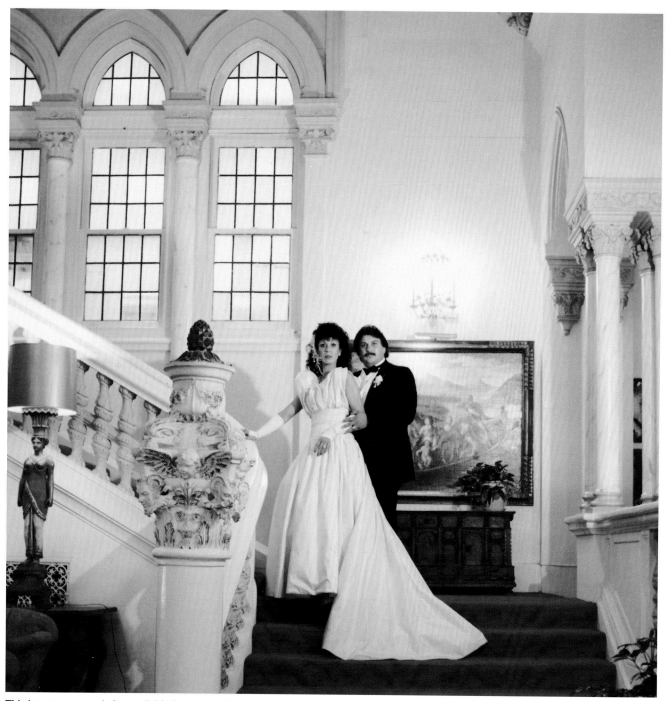

This image was made by available light only. Although it is more formal than romantic, it is an important reminder to the couple of where their reception was held. When working on location, examine the area well. Let your reaction to it guide you in deciding whether a formal or a more casual image would be in order. Because of this location's special beauty, formality seemed the better posing choice.

At the reception, you can often find a wall mirror that can be used to make a simple image look stronger and more appealing. For this photo, a single on-camera flash was used to illuminate the groom. The shutter speed was set two full *f*-stops slower than the meter indicated from an incident reading taken at the bride's position. This compensation also took into account the darkness of the bride's mirror image.

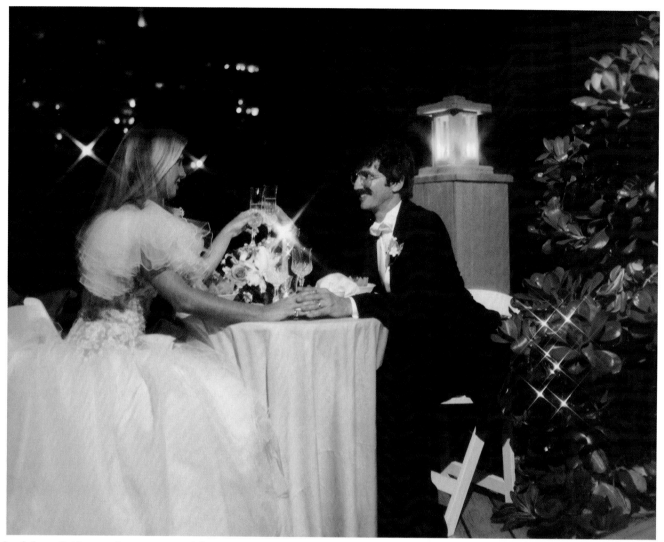

Look for suitable remote areas around the reception site that might lend themselves to romantic images. Then, during the reception, lead the bridal couple to such an area and pose them as if they were the only people around for miles. This photograph was taken primarily by ambient light, with a single on-camera flash as a fill source. The use of a starburst filter added to the dream-like quality of the image.

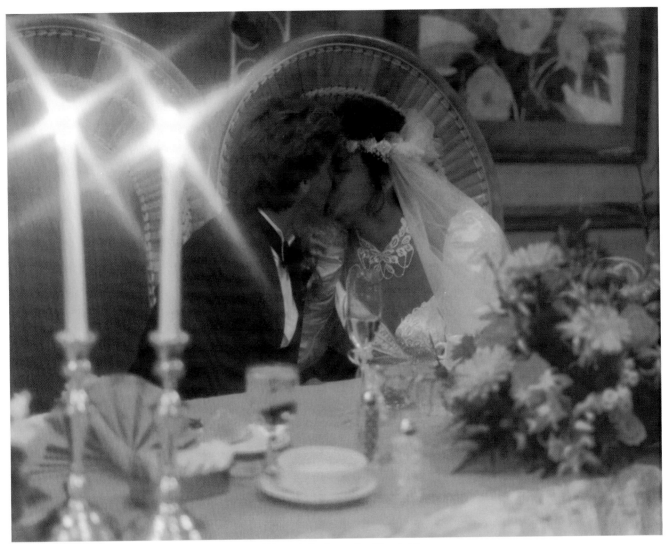

This photograph was made solely by ambient light. Although the face of neither bride nor groom can be clearly seen, such an image offers a great wedding-album contribution.

8

The Cocktail Hour And Reception

The cocktail hour and the reception are the last two phases of the wedding celebration. It is customary to have both at the same place—the cocktail hour first, followed by the reception. During the cocktail phase some form of snack is usually served or a buffet table prepared and there is usually music. It is customary at the reception to serve dinner—lunch, if it's an early affair—or to have a more elaborate buffet table, and the musical entertainment is usually more elaborate than during the cocktail hour.

Of the two phases, the reception is definitely the harder one for the photographer. Everyone—bride, groom, family friends and guests—will be having fun, with a few of them even throwing caution to the wind. The photographer cannot afford to become distracted by all the frivolity. This does not mean you should not enjoy yourself, but you must not let your enjoyment lure you from your professional task.

Although not all weddings include a cocktail hour, almost all of them do have a reception. And, as all weddings differ, so will the receptions.

Nevertheless, there will be a common thread: Everyone will be seeking a good time. This generally will create an atmosphere of excitement and it's fun and easy to photograph exciting things. However, there will be times when the crowd at the reception will be less than exuberant and the affair may even be somewhat dull. This will be no excuse for the photographer not to get all of the required images.

The Cocktail Hour

The cocktail hour will occur immediately after the ceremony and before the reception and will usually last about one hour. Its purpose is to afford the guests some free time to mix. This is when the photographer will do his formal photographs at the altar, followed by his first series of romantic photographs of the bridal couple. That's OK because, photographically, the cocktail hour is generally pretty fruitless anyway.

In our experience, brides rarely buy photographs of this phase. There are too many other images from before and after this event that are im-

portant and more representative of the day. Even if you have the opportunity, we recommend that you do not spend much time or film on recording the cocktail hour. Ten minutes with a single on-camera flash will generally suffice. Use any time remaining to ready yourself for the reception.

WHAT TO SHOOT

There are no must-get shots in the cocktail-hour phase. However, the following frosting shots do help to round out any bridal album:

The Ice Sculpture—If there is an ice sculpture, it will generally be carved in the shape of the bridal couple's initials or some other symbol that has some special meaning to them.

A General View—Shoot a general, wide-angle view of the room in which the cocktail hour is held.

Bridal Couple and Guests—Take a few photographs of selected guests with the bridal couple or the parents of the couple.

The Buffet Table—Take a general view of the buffet table, before the guest have had an opportunity to help themselves from it.

The Reception

Any wedding reception must be structured. Whether it be planned by the bride, her mother, a bridal consultant, the bandleader, the caterer or the wedding photographer, or by a combination of all of their efforts, it must have a beginning, a middle and an end. If it doesn't, almost as soon as it is under way the guests will become bored by the lack of festivities and organization and they will leave.

Whether the affair be a modest one or an elaborate sit-down dinner with champagne for 300 people, costing thousands of dollars to produce, don't assume the principals will know what to do or how to do it. Generally, they won't. The bride and groom will look around for guidance and that guidance should come from you. You want them to rely upon you. Not only will you be helping them through unsure moments but you will also be setting up photographs as you wish.

THE PHOTOGRAPHER'S ROLE

The experienced photographer does not wait for a reception's events to come about. He makes things happen by improvising activities to give the appearance that everyone is having fun. He then photographs those situations. Otherwise it may soon all be over and the only thing you will have to show is one exposed roll of film of boring images mainly of people eating and drinking.

Furthermore, not only must the photographer capture all these joyful, candid events but he must also photograph certain situations representative of the occasion that will fit logically into a bride's album.

Everyone at the reception—the bridal couple, the bridal party, family, friends and guests—have waited for this phase of the wedding. They are prepared to unleash the pent-up tension of the day—to have a party. Consequently, as the official wedding photographer, you become somewhat of a thorn in their sides by impeding their fun. If you wait, however, until all the people you want to photograph are ready to be photographed, you'll wait all night and still not get the images you need. You must be politely persistent.

The Wedding Consultant—Sometimes, especially for the more elaborate affairs, a bride or her family will hire a special wedding consultant to co-ordinate the wedding events. One would think that this would make the job for the photographer easier. It won't. Don't rely on any such person to do any of your work for you, or to do it correctly.

If a wedding consultant is present, be polite, offer your cooperation and assistance, then do what you have to do on your own. Don't wait for him or her to help you and above all do not let the consultant orchestrate your photography. On most occasions, the consultant, like everyone else at the affair, won't have the faintest idea of what will look good photographically or how to arrange for the photographs you need.

Some consultants may be rather forceful and attempt to "run your show." Don't let them do it, but in no way get involved in any altercation either. Use diplomacy and work around the problems you may encounter, or in spite of them.

If a consultant advises you to take a certain photograph and you do and the results are poor, you will be the one blamed. If the results are good, the praise will go to the consultant and your subjects may wonder how much better your other photographs might have been had you had the consultant's help.

If the consultant's advice was sound, store it in your memory and use it for your next affair. Then it will be "your" idea.

The Wedding Caterer—At all the receptions we have attended where food was served, there has been someone in charge of the service—the caterer. Usually the caterer will present no problems for you until the cake-cutting at the reception.

When you first arrive at the site of the reception, one of the first photographs you should take is of the bridal cake. To give dimension to the cake, two lights should be used. The cake table will usually be placed near the bridal dinner table or off to the side near a corner.

Ideally, at the time the bridal couple is to cut the cake, the cake table should be moved to the center of the dance floor so that all of the guests can watch. However, often the caterer will object to having the cake moved; he'll be fearful that the cake will tumble or break apart. Don't fight that decision but choose your camera angle carefully. Avoid having a blank wall as the background or, even worse, a pile of dirty dishes. Try, rather, to place some of the guests or family members there.

The caterer may wish to stand next to the bridal couple to assist them with the cutting of the cake. Don't let him do it. Ask him to move; otherwise he will be in all of the photographs, and they will not sell.

The Bandleader—At most receptions music will be provided. It may be furnished by a disk jockey, a three- or four-piece band, a 10-piece orchestra or various other combinations. In any case, there will usually be someone in charge, whom we'll call the bandleader. This person usually will have the additional job of controlling the timing of certain standard events such as the bride and groom's first dance, the bride's dance with her father and the cake cutting.

Soon after your arrival at the reception site, approach the bandleader, introduce yourself and ask him to keep you informed, in advance, of all the events he intends to announce. You want to be prepared to photograph any major undertaking before it

happens. Nevertheless, don't rely totally on his fulfilling your request. Unless he has worked dependably with you before, you cannot afford to place your photographic coverage into his hands.

If the bandleader forgets to have a first dance for the bridal couple or if he forgets to have a bridal bouquet toss, you must arrange for it. If, during the removal of the bride's garter, he places a chair in the middle of the dance floor at an angle inappropriate for good photography, you must move it.

If the bandleader does announce the bridal couple's first dance but forgets to tell you in advance and you are unavailable at the time, it will be your fault for not getting the needed photographs, not his. It's as simple as that.

Always remember, you alone are in charge of the wedding photography. When the results are outstanding, you alone should receive the accolades. When you fail, only you are to blame.

Protect Your Equipment—No matter how modest or elaborate the wedding, the possibility of theft of, or tampering with, your equipment always exists. It is said that experience is the best teacher; however, you should not have to experience a disaster to be prepared for one. Use common sense. Stay alert. Place your equipment in a safe place, either within your view or with an assistant, wherever you are in the reception area.

If you do not have an assistant to help guard your equipment, keep enough equipment on your person—such as your camera, on-camera flash and extra rolls of film—to enable you to finish your task despite possible theft or tampering. It will be no consolation to the people who hired you to hear that you cannot finish because some major piece of your equipment was stolen or damaged.

SEQUENCE OF EVENTS

The list below comprises the typical order of events at most receptions. Because the sequence can vary, the thing to remember is that all of the events listed should happen unless the bride has informed you otherwise.

1. Entrance. Often the entire bridal party will be announced by the bandleader as each couple walks into the reception room area. The bride and groom will always be announced and be the last couple to enter.
2. Bride and groom's first dance.
3. Each couple in the bridal party is then invited to dance.
4. Parents of the bridal couple are invited to dance.
5. Bride dances with her father-in-law and then her father.
6. Groom dances with his mother-in-law and then his mother.
7. Prayer or blessing over the bread.
8. Toast to the bridal couple, usually by the best man.
9. Main meal.
10. Cake-cutting.
11. Bouquet toss by the bride.
12. Groom's removal of the bride's garter.
13. Garter toss by the groom.
14. Garter is placed on the leg of the girl who caught the bridal bouquet, by the man who caught the garter.
15. Bridal couple leaves the reception for the honeymoon. This is the time for the rice throwing.

The events will usually take three to five hours, with some happening one right after the other. For example, when the bride is invited to dance with her father, within a minute or so the groom is invited to dance with his mother.

MUST-GET PHOTOGRAPHS

Whether they come about naturally or are arranged, the following photographs must be taken for adequate

coverage of this phase:

1. Entrance of the bridal couple into the reception room.
2. Bridal couple's first dance.
3. Bride dancing with her father.
4. Groom dancing with his mother.
5. Toast of the bride and groom by the best man.
6. The bridal cake, by itself.
7. Bridal couple cutting the cake.
8. Table images: One view of the bridal table and one each of the tables of the groom's and bride's parents. Make certain that all persons assigned to each table are present.
9. Bouquet toss by the bride.
10. Bride's garter being removed by the groom.
11. Garter toss by the groom.
12. The exit: Bride and groom waving goodbye or getting into their car to leave and the rice throwing. Any wedding album must show a logical ending to the events of the day. This picture generally serves that purpose.

FROSTING PHOTOGRAPHS

Add the following photographs if time and the bridal package selection permit:

1. Group photographs of various family members with the bridal couple.
2. Group photographs of the groom with his friends.
3. Group photographs of the bride with her friends.
4. Bride with her mother.
5. Bride with her father.
6. Bride with both of her parents.
7. Groom with his mother.
8. Groom with his father.
9. Groom with both of his parents.
10. Bride dancing with her father-in-law.
11. Groom dancing with his mother-in-law.
12. Table images: Views of all tables in the reception room, making sure that all of the assigned

guests are at their tables.

13. Wide-angle, time exposure views of the entire reception room.

14. Bride feeding a piece of bridal cake to the groom and the groom feeding the bride.

15. The girl who caught the bridal bouquet, with the bouquet.

16. The bride hugging the girl who caught her bouquet.

17. The man who caught the garter, with the garter.

18. The groom shaking hands with the man who caught the garter.

19. If applicable, the bride dancing with each of her brothers and the groom with each of his sisters.

20. Exit: Attempt to photograph the bride's parents as they watch their "little girl" driving off in the bridal limousine. Deep emotion may be displayed. In addition, photograph the bridal couple's friends as they wave goodbye.

21. The bridal car alone, if it is decorated.

The Wedding Day Is Over

So ends a day in the life of a wedding photographer. By the time you finish, you should be tired and ready to leave. However, before you do, approach the bride's mother and father, if the bride was the one who hired you, extend your congratulations and thank them for allowing you to be of service and to participate in their daughter's wedding. In addition to being a normal gesture of goodwill and good manners, it will go a long way in promoting you and your future business dealings with the bride's family.

One final word: Be certain you take away all of your equipment and film. Don't leave valuable gear back at the reception area or, worse, some or all of the film you have just exposed.

Photos in This Chapter

Unless otherwise noted, all the photographs in this chapter were taken with the following equipment and at the following exposures: Hasselblad camera; standard or wide-angle lens; single, portable on-camera flash; flash adjusted to emit *f*-11 light and the camera set at *f*-8 and 1/60th second.

A bride may have special wine glasses, or a candle etched with her wedding invitation, that she intends to display at her reception. Prior to the wedding day, ask her to bring these items to you so you can photograph them at your leisure and under controlled conditions. Such a photograph makes a beautiful addition to a wedding album. This one was taken with two Balcar lights housed in Chimera soft-boxes and a starburst filter. The main light was aimed from about 45° to the right of the camera-subject axis and the fill light was aimed from about 45° to the left. The fill light was set to emit one-half the power of the main light.

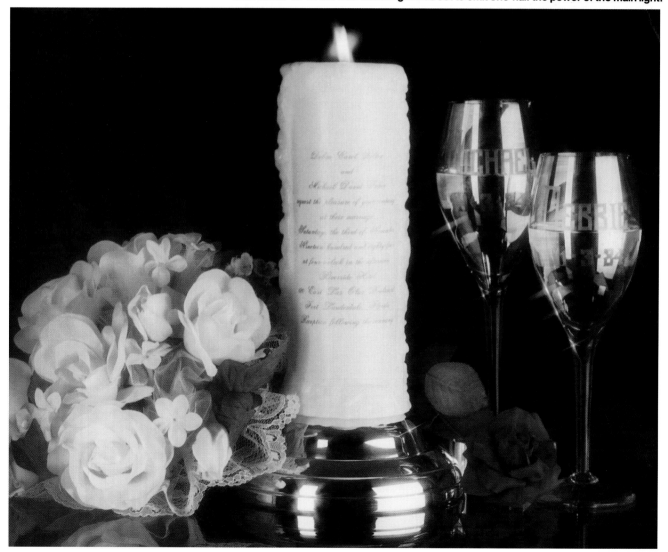

Usually, a bride will have a guest book at the reception for all of the guests to sign. A photograph of this book can be an attractive addition to a bridal album, if you shoot it in the right way. A quick, simple photograph with an on-camera flash will have little appeal. For the photograph here, the guest book was moved and arranged with other elements nearby—candles and flowers—to make the image more appealing. Only available light was used, along with a starburst filter. The camera was on a tripod. The exposure was 1/2 second at ƒ-8, which was one full ƒ-stop more than the incident-light meter reading had indicated.

A photograph of the bridal couple being announced at the reception is a "must-get." Watch your angle of view and background carefully. Include happy onlookers in the scene and exclude dirty dishes.

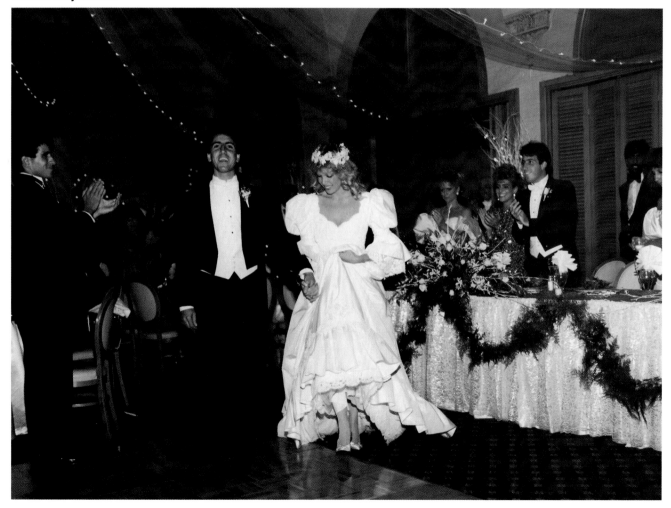

It is important to photograph the bridal couple's first dance. Of course, it's critical to have both of their faces turned toward the camera.

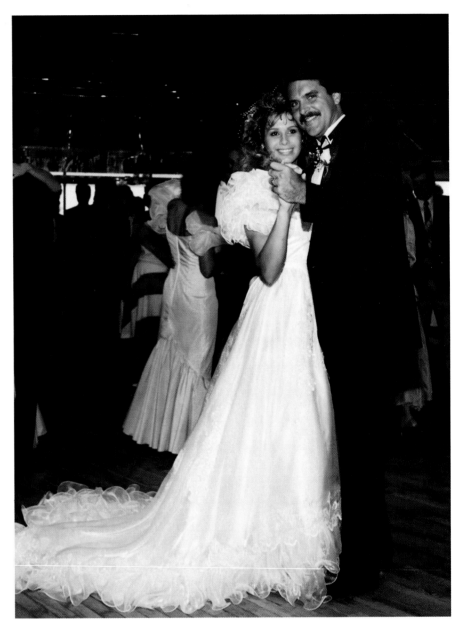

During the course of most receptions, you'll see genuine love and tenderness being displayed. This one, of the groom embracing his grandmother, is typical. Candidly capture these moments on film. Such images give warmth to any bridal album.

Children are born actors and most of them love to be photographed. Almost any photo of a child interacting with an adult will be a winner.

At most receptions, someone close to the bride or groom—often the best man—will stand to give a speech, wish the bridal couple well, and toast their happiness. Usually, you will have to arrange this scene, otherwise the person giving the toast will be up at the bandstand, with microphone in hand, and the bridal couple will be somewhere else in the room listening to his speech. When you see that a toast is about to be made, lead the bridal couple—along with their wine glasses—up to the person about to give the toast and have them stand next to him. The resulting photographs will have much more meaning and appeal.

Don't hesitate to take the groom and all of his ushers aside for a photograph or two of them in a relaxed atmosphere. Such views sell. This one was executed with a wide-angle lens and a single on-camera flash.

Most receptions are a lot of fun and can produce some unexpected events, as captured here. Be prepared to act quickly.

Often a bride will want photographs of the guests at their tables. For a conventional table view such as this, with some of the guests standing and others seated, use two lights, with one of them off-camera and slaved and both set to the same power output. This will afford even illumination. Try to take the table photographs at the beginning of the reception, when the tables are still neat and clean.

When you first arrive at the reception, photograph the bridal cake by itself. In case the cake melts or becomes damaged during the reception, you will have it fresh on film. Ideally, you should use two lights—an off-camera slaved light about 70 degrees to 90 degrees to the right or left of the camera-subject axis and an on-camera flash as a fill light. The fill light should be set to one-half the power of the main light. Such lighting will produce good texture and detail. If time or space doesn't permit this arrangement, a simple on-camera flash will suffice. Be sure to have a clean, attractive background.

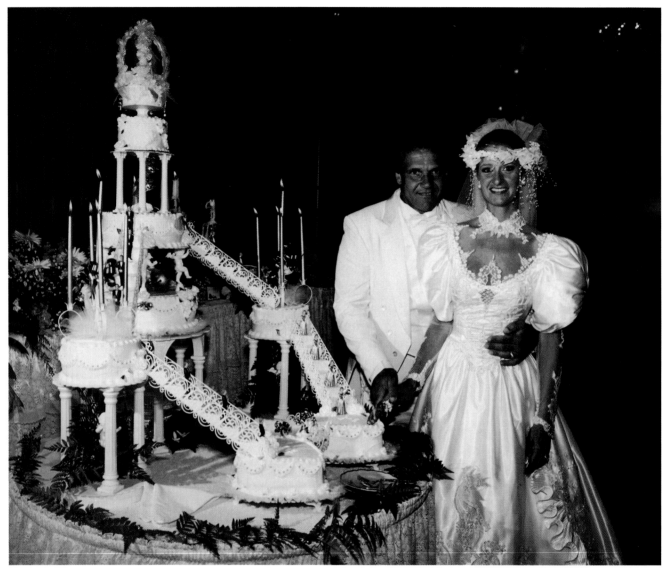

No wedding album is complete without an image of the bridal couple cutting the cake. Whether you use two flashes or one, available light or a combination, the photograph must contain all of the information—the bride, the groom and the entire cake.

Tradition calls for the bride to feed her husband the first piece of cake. Often, a bride will gently place a piece to the lips of the groom and allow him to nibble at it. But be prepared for the unexpected. She may become playful and push a large piece into his mouth.

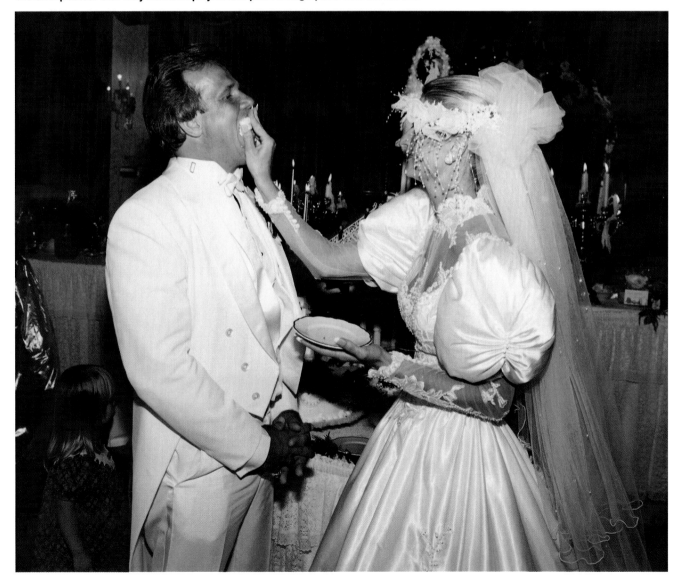

If the bride becomes playful, you can be sure that the groom will respond in kind. Such photographs are "must-get." They make a bridal album fun to look at. Make sure, if possible, that you can see at least the sides of both of their faces.

After the cake-feeding, photograph the couple kissing. How they do it you should leave to them. Just instruct them to kiss and let them take it from there. However, if, for some reason, the camera angle or the lighting does not satisfy you, shoot it again. The couple will not mind. Using different lighting for a second view will also offer a little more pictorial variety. This photograph was made by available light, and with a starburst filter.

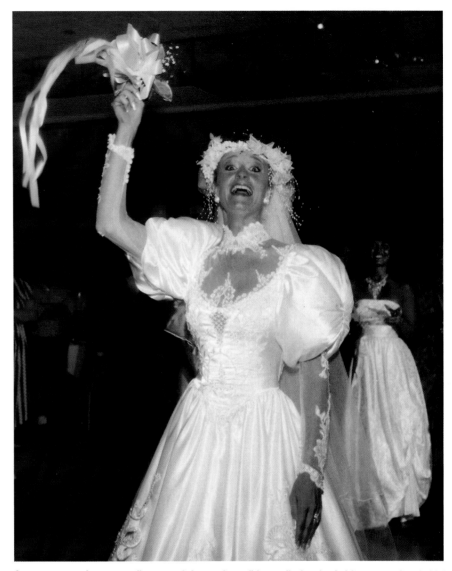

At most receptions, usually toward the end, tradition calls for the bride to toss her bridal bouquet toward all of the unmarried women at the party. The one who catches it will be the next person married, so tradition says. In photographing a bouquet toss, two factors are important—camera angle and timing. Make sure you are on the side of the bride away from the arm she intends to use to throw the bouquet. As she raises the bouquet to throw it, you do not want her arm blocking her facial expression. Take the shot just as she is about to throw the bouquet, or the actual moment it leaves her hand. This will capture the bouquet close to the bride.

Don't think a bride's throwing her bouquet is just a silly tradition. This view shows that catching the bouquet may be taken very seriously.

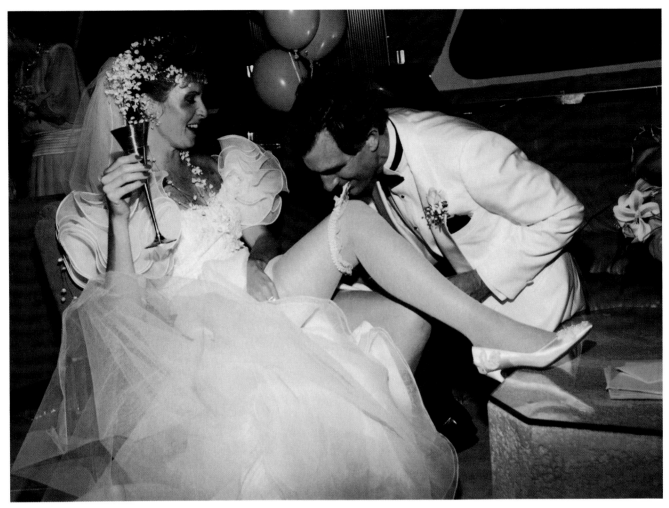

Toward the end of the reception, tradition calls for the groom to remove the bride's garter from her leg. Often this is done in a conventional manner: The bride is seated, the groom kneels, the bride raises her dress slightly and the groom gently slides the garter off. Frequently, however, the bride and groom become a bit more flamboyant, as here. In any case, it's a must-get photograph. This one was executed with a single on-camera flash. Ideally, your camera should be on the side of the gartered leg and you should be able to see at least the sides of the couple's faces.

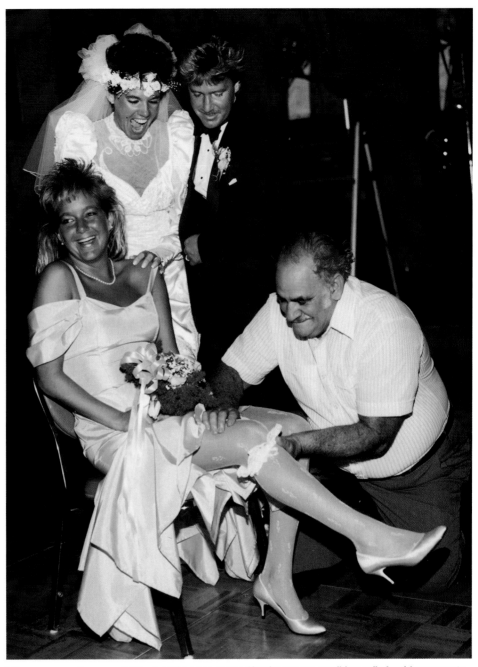

After someone has caught the bridal garter, tossed by the groom, tradition calls for this person to put it onto the leg of the woman who caught the bridal bouquet. Make sure you place the bridal couple slightly behind these two, so they are included in the picture. This image was made with a wide-angle lens and a single on-camera flash. As with the garter removal photograph, make sure you are on the side of the leg that is to receive the garter.

Throughout the reception, watch for opportunities to photograph open signs of emotion. The angle of view would have been better had the camera been slightly more to the right. However, the presence of a crowd and the shortness of time forced shooting the picture instantly or missing it. Such an image cannot be recreated; the impact will have been lost.

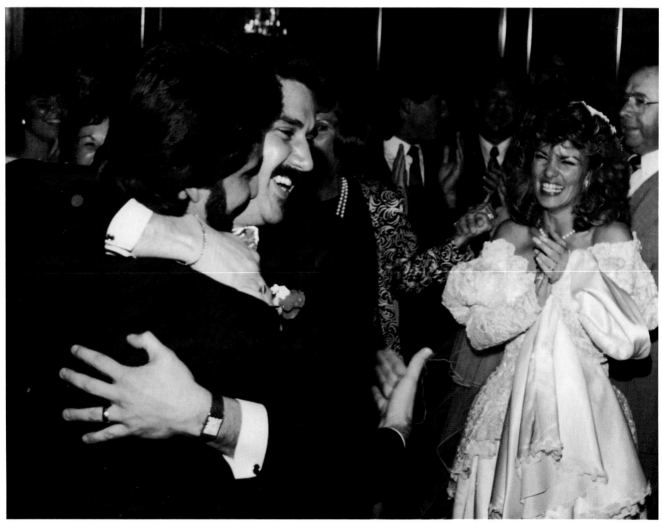

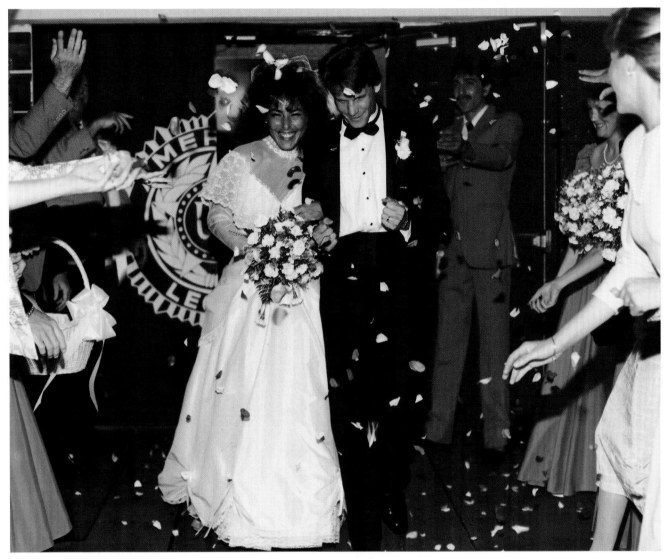

If a bride has planned the throwing of rice or rose petals, this will usually take place at the end of the reception. The critical thing to find out is the exact route the couple will take as they leave the reception. Then, position yourself directly in their intended path. Focus on a point about 10 to 12 feet from the doorway. As they reach the point of focus, take the photograph, using a single on-camera flash. You will usually have time for only one or two photographs, so be prepared. This scene cannot be recreated.

Often the aftermath of the rice throwing can yield other interesting candid views, such as this one. These photos help round out the wedding story.

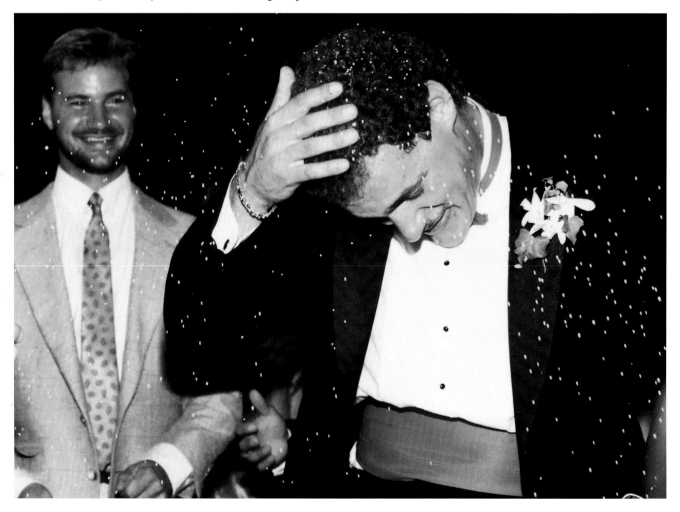

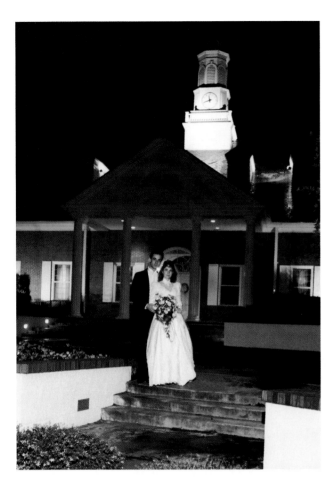

To help document this couple's reception and show where it was held, they were led outside and posed in front of the site. This was done when the reception was almost over. A wide-angle lens was used, along with two lights—one off-camera slaved light to act as the main source and one on-camera flash as a fill source. The fill light was set at one-half the power of the main light. The shutter speed was set to record the ambient light on and about the building.

Every bridal album should have a logical conclusion. There are many possibilities, ranging from an interpretive view of the bride and groom's shoes and clothing scattered on the floor leading to a half-open door, to the more common view of the bride and groom standing in a doorway and waving goodbye. As long as you convey the sense of departure, you have accomplished the goal. This shot required only a single on-camera flash.

This goodbye view, with the bridal couple sailing off into their new life, was made with a 150mm lens and available light.

The Business Of Wedding Photography

Wedding photography can be profitable as well as fun. However, to be successful at it, you must approach it in a professional manner and constantly be prepared to learn and put forth as much effort as you can. There are no shortcuts or get-rich-quick schemes. The ingredients are hard work, careful preparation, good equipment and informed judgment. The result, with perseverance, can be a good, competently executed photographic product. If you take the business seriously, your only limitations will be self-imposed ones.

Whether you're already in wedding photography professionally or are intending to enter it as a new career, we would like to help make your journey easier. In this chapter, we'll discuss four important aspects of the business: How to attract business, book a wedding, present previews or proofs, and get the order.

How to Attract Business

There is a customary sequence of events that precedes most weddings. First, a bride becomes engaged. This usually means that a jeweler has been consulted. Second, the bride shops for her bridal gown. Third, a bride seeks a ceremony and reception site. Fourth, she hires a band, a florist, a caterer—and a photographer.

Although the order can vary, our experience has been that before a bride hires us, she has purchased her gown and arranged for the ceremony and reception site. Once she has established the wedding date, she will look for a photographer, florist and band.

It is important, therefore, to make contact with the owners of the better known jewelry and bridal shops in your area to let them know that you want to do wedding photography. It definitely helps to get you business.

There's a wide variety of ways to get business. We suggest you particularly explore the following avenues.

BUILD A PORTFOLIO

In the beginning, you may not be armed with many samples of wedding pictures to show to prospective customers. You may not even have any to show. That, of course, is a great drawback. Therefore, one of your first tasks must be to build a sample book of wedding photographs—a portfolio.

You are in a visual medium. You can tell someone how good you are and what you will do for them, but most of your customers, quite rightly, will have a "show me" attitude. They will want to see some evidence of your ability and talent as a wedding photographer.

In the early days of your wedding photography, when you have no or few prints to show, you may have to cajole friends, family and acquaintances into allowing you to photograph their weddings, all at no charge or for only the cost of the film and processing. The main purpose, as far as you are concerned, will be to build up a portfolio of sample photos.

As an alternative, you might have to hire yourself out as an assistant to a wedding professional with the understanding that you will be paid in prints—reproductions of photographs you have taken at each affair. **Presenting Your Portfolio**—Once you have samples or proofs of your work to show, be sure to display them in the most impressive possible way. Don't make the mistake of using a

cheaply-bound binder or album. Put your sample photos in the best album that you intend to sell. Make sure that all of the photos have been retouched, spotted and sprayed. Place them in chronological order.

How you present your work is almost as important as the work itself. If you don't think highly enough of your work to show it to the very best advantage, you can't expect prospective customers to be impressed.

CHOOSE A GOOD LAB

At our studio we have the luxury of processing our own film and enlarging our own prints. This gives us almost total control over the result. However, for most of you, processing and enlarging will have to be farmed out to a professional laboratory. Choose carefully. A lab can make or break the best of photographers. You will literally be putting the financial outcome of each wedding you do into your chosen lab's hands.

Talk with other photographers in your area and get their recommendations. Then visit the chosen lab, examine the facilities and determine the quality of work done there. In addition, get a detailed list of services, rates, costs and delivery times. You will need all of this information before you can accurately quote a prospective bride a fee for photographing her wedding.

BUSINESS CARDS

Business cards are extremely important and a photographer's card should be especially distinctive visually. People must be able to remember you by your card. Think of a new, fresh way of presenting yourself. If you can't do it yourself, hire someone to design a card for you that will represent what you do and reflect your artistry.

There are many business items you will be able to save on or initially not invest in, but your business card should not be one of them.

TALK SHOP

To get business, ask for it. A successful business person is not faint of heart. When at the barber shop, gas station, cleaners or clothing store, strike up conversations and let people know what you do and how good you are. You may be hesitant at first to shout your own praises, but until you have a clientele to do it for you, you must be your own agent. Be enthusiastic about your profession and about photography. It's contagious. People will remember how thrilled you were when talking about what you do.

ENTER BRIDAL SHOWS

In our area, bridal shows are conducted several times during the course of each year. A bridal show consists of business people who service weddings getting together under one roof to display their wares to prospective brides and their families and friends. Such shows will usually have two or more of each type of business represented, with the exception of the host business—often a bridal-gown or tuxedo shop. Bridal shows can be great sources for future wedding business.

Cost and Length—Depending on how much space you plan to take, the cost can vary between $200 and $1,500 per show. A show can last anywhere from one evening to two full days. The cost is dependent on the extravagance of the show, the location, the time of year and the amount and cost of advance advertising.

The Value to You—Depending on the size of the bridal show and its extravagance, you may see as many as hundreds of prospective customers during the course of one evening.

In addition, the host will usually give you a mailing list of all of the people who attended the show—a great source for your follow-up

advertising and promotions.

You will also get the opportunity to meet representatives of the other related businesses and of letting them know of your work.

The wedding circuit comprises relatively few businesses. The better ones are often at all of the better wedding affairs. At bridal shows, you can become known among this group—caterers, florists, bands and bridal shops—and soon you'll start to get business from them.

How to Enter a Show—Watch your local newspaper to see when the next show is coming to your area. At the same time, start calling the better bridal specialty shops and tuxedo rental shops in your area and inquire when the next show is to occur and whom to contact. They'll be more than responsive to you.

BRIDAL AND TUXEDO SHOPS

Visit each of the better bridal specialty shops in your area. Show samples of your work and offer to photograph free anyone the representatives choose, in bridal gowns or tuxedos, in exchange for permission to display there some 16x20 prints of the results. Most will not refuse you. At the time you deliver the prints to them—on loan—they will usually ask you to leave some business cards so that they can recommend you to prospective wedding customers. In addition, they frequently will supply you with a mailing list of their prospective wedding clientele.

YELLOW PAGES

This form of advertising has not proven effective for us in obtaining wedding business, although it has been productive in our other areas of photography. We continue with it, however, because of the other photographic business we get and because we think it important to keep our name before the public.

If you elect to advertise in this man-

ner, study your competition's ads carefully and make yours different. An ad similar to your competitor's is likely to be ineffective and wasteful.

PUBLIC DISPLAYS

Ask permission to put up a display of your photographic work at local banks, good restaurants, your city hall, your local theater and other public places. A number of places are sure to turn you down flat. However, if you persevere, some will capitulate. Once you have your foot in the door, your work will keep you there, season after season. Try to show 10 to 20 pieces of your work—impressive enlargements, 16x20 and larger—a couple of times a year, for two to three weeks at a time.

TELEVISION

This is an expensive way to get new business but it is effective. However, if you are going to use this medium, you must be prepared to advertise consistently one or two times a day, several days a week, for a couple of months at the minimum. The repetition is essential if you're going to get your message across.

CATERERS, FLORISTS AND BANDS

All of these are good potential sources for new business. Once you begin to do weddings regularly, you'll start to see the same faces over and over again—the same florists, caterers and band members.

While at a reception, take a few minutes for some photographs of the buffet table or sweet table, the floral centerpiece or other attractive floral arrangement, and group shots of the band. When you print your wedding order, print some of these extras as 8x10s to send to these people, at no charge.

Include a complimentary note with the prints to say how nice you thought their displays were or, in the case of

the band, how well they looked and sounded, and that you thought they might like photographs for their portfolios. They will love you for it and remember you. Your foot will be in the door for referral business.

BRIDAL MAGAZINES

In our area, the larger specialty bridal shops publish, or have published under their auspices, monthly or quarterly bridal magazines. Such magazines usually contain tips for the bride-to-be on honeymoon locations, how to shop for a florist and photographer, time- and money-saving tips on preparing for the wedding day. They also contain advertisements from businesses that cater to weddings. Although we cannot directly attribute any of our wedding business to such ads, we continue them because they help to keep our name before the public.

WORD OF MOUTH

Customer referrals are the best form of advertising any business can have. Based upon a survey we took at our studio, more than 80 percent of the weddings we booked during a six-month period came to us through recommendations by former bridal clients.

Customers obtained in this way are sold on you and your photography in advance. However, initially this is a very slow way of getting business. It takes time to build up a clientele—but don't despair. If you do consistently good work, the word-of-mouth method of getting business tends to snowball.

WHAT NOT TO DO

Several years ago, when first starting our business, we were approached by the general manager of a very large restaurant and reception hall. His proposition was simple: Pay him $10,000 and he would guarantee—in writing—to refer a

minimum of 10 bridal customers to us per week. We declined. The last time we heard, the manager had skipped town and the restaurant had gone into bankruptcy.

So-called "get-rich schemes" are everywhere and permeate every business, and the wedding business is no exception. Avoid them. They are likely to lead you to financial disaster.

Don't misunderstand; there is nothing wrong with exchanging referrals. It's done all the time. For example, if you find a florist in your area who does exceptional work, tell him you have brides that often ask you for a recommendation for a florist and you would like to refer business to him and expect nothing in return. Not only will he be greatly appreciative but he will also respond by referring bridal business to you.

Booking a Wedding

Before you can book a wedding, you will need a printed price list of the various bridal packages and photographic services you intend to offer. We would suggest you visit other photographers in your area and see what they are offering and charging. Use this information as a guide when structuring your price list. In the beginning, you may charge less than they do. However, as your work and experience improve, so can your prices.

Once you are armed with a price structure, your initial contact with a prospective customer, whether by telephone or in person, will be a critical step. If you handle it properly, not only will you close a sale, you're also likely to make a new friend. Often such a customer will refer business to you even before you actually photograph the wedding.

THE TELEPHONE: A STRONG TOOL

Most successful photographers

would probably agree that, beside their camera equipment and their knowledge of photography, their telephone is one of the most important tools of the trade. Entrust your telephone business only to people who are truly familiar with your work and your price structure. Of course, your phone contact with prospective customers must also be friendly, courteous and enthusiastic. He or she is, in effect, the window to you and your studio.

Most of our bridal customers call our studio first, checking our prices or availability, before coming into our studio. Because the first contact most customers have with us is by phone, we do not consider an answering machine or a telephone answering service acceptable. Only a knowledgeable person, with the customer's interest in mind, should be handling your calls and your phone should never be left unattended during normal business hours.

Go After Information—When you have a prospective bride on the phone, get as much information about her and her wedding as you can. Don't just coldly respond to her questions. Be interested in what she is saying and try to be of assistance. Most prospective brides don't know what questions to ask and what information they should get, so help by volunteering as much information as you can.

Your Prices and Your Work—We in the wedding photography business need to remember we are not engaged in the usual type of retail trade. If we were selling a Brand-X stereo, for example, and someone were to call inquiring about its price, the caller could shop this price by calling other dealers. In the photography business, price is not the main consideration.

While it is a fact that someone can ask how much your wedding prices are and then compare them with another photographer's bridal packages, it is the wrong approach. A print from you is different from anyone else's. You are engaged in an art form as well as a business and thus your style becomes the main consideration. You may want to be competitive with the other photographers in your area, but price should not be the sole or main basis of distinction. Your work should.

One of the first questions you should ask callers, then, is "Are you familiar with my work?" If they are, you have half the battle won. If they are not, inform the callers that what they are paying for is not pieces of photographic paper, which cost only a few dollars, but your style and imagery. Invite them to come and see your work, without obligation.

YOUR FIRST MEETING

You must make your first face-to-face meeting with your prospective customer an impressive one because most people judge others by first impression. From the moment a prospective bridal customer comes into your studio or home, she will consciously or subconsciously be evaluating you and your work.

Demeanor and Attire—Whoever books the weddings—you or someone you have hired to do the job—must be neat, clean, personable, well-dressed, well-spoken, well-mannered, knowledgeable about you, your work, your pricing and your services and anxious to serve the needs of the prospective bride.

Offer some refreshments and make the prospective bride feel comfortable and relaxed and anxious to stay with you to hear what you have to say, and to see your work. You have a willing audience, so capitalize on it.

Physical Surroundings—Whether you are operating from your home or from a studio, set apart an area for interviewing prospective customers. It should be clean and neat. Put examples of your work on the walls and have bridal albums available to be looked through.

Interruptions—In the beginning of your career you may not be troubled with your phone ringing off the wall and customers coming in and out throughout the day. However, "positive" problems tend to grow with a business. When this begins to happen, you should arrange not to be interrupted for anything other than an emergency once you begin to talk with a prospective customer. The bride-to-be deserves your full time and attention.

Other Photographers—Attempt to learn whether you are the first photographer the bride has seen. If you are one of many, try to learn what it is she likes and doesn't like about the competition's work. Listen intently to what she has to say and then address yourself specifically to those areas. Tell her how your work differs, but do it without being petty or putting another photographer down. You can distinguish yourself and your operation from others without such measures.

WHAT YOU NEED TO KNOW

Even though you may have had a previous telephone contact with the prospective bride and amassed a lot of information about her wedding, make certain you review all of it with her. The essential information you should get from her is as follows:

1. Bride's full name, address, work and home phone numbers.
2. Groom's full name, address and phone numbers.
3. Names and addresses of the bride's and groom's parents.
4. The number and names of the bride's and groom's brothers and sisters.
5. Date of the wedding.
6. Exact time of the ceremony and reception and the exact location of each.
7. Bride's address after the wed-

ding date.

8. Where the bride will be dressing for her wedding and the exact time.
9. Number of bridesmaids and ushers.
10. Whether there will be a flower girl and a ring bearer.
11. The number of invited guests.
12. Special problems: For example, her parents are divorced and do not wish to be photographed together.
13. Special requests: For example, the bride may dislike photographs taken with soft focus or she may want very few posed photographs and desire only candids, or she may love romantic photographs.
14. Ascertain what is really important to her with regard to her wedding photography: For example, she may consider photographs of her entire family the most important thing among her wedding pictures.

Enlist Cooperation—Once you find out how important the wedding photographs will be to her and her family, you must convey to the bride that competently executed wedding photography does not just happen but is created and takes a certain amount of time and preparation on your part and cooperation and time on hers. Ascertain how much time and cooperation she is willing to give you on her wedding day and in general outline the photographs you will do and how long it will take you to accomplish each phase of photography.

Who's the Boss—Stress to the prospective bride that if she hires you, you will work for her and around almost any schedule she has in mind. In addition, you will attempt to adhere to almost any photographic request she might have. For example, some brides may want only photographs with soft focus, and others will want none.

GETTING DOWN TO SPECIFICS

Offer the bride your printed price list for her to examine and point out what each of your bridal packages includes and how the bridal packages differ. Inform her that there are no hidden gimmicks or surprises. Let her know that if none of your bridal packages meet her needs you will tailor a package to accommodate her and her budget.

Personally Show Your Work—Don't simply place a wedding book in front of the prospective bridal customer and allow her to thumb through it, looking at all the pretty pictures. Usually, she will not know what to look for other than to see whether, in general, she likes them or not. You should have placed selected images into your preview book for specific reasons. Go through the book with the prospective bride and point out the reason for putting in each photograph—what it is conveying or demonstrating.

Ask for the Business—After you have finished covering all of the above areas, directly ask to be assigned to photograph the wedding. Use whatever words you wish, but ask for the opportunity to be the official photographer at the bride's wedding.

If she says no or that she wants to think about it, attempt to find out what is causing her indecision and specifically address it. Remove as many of the obstacles as you can from her decision-making process.

If you are not hired on the spot, book the wedding anyway. Reserve the time for a period of five days. If you receive a deposit within that time, the wedding is officially booked. A wedding is not *officially* booked until you actually get a deposit in hand. The amount of the deposit is not as important as the act of financial commitment.

Deposit and Balance Due—At the time of writing this book, we require a $200 deposit with most of our bridal packages and a $500 deposit with our most expensive package. Our policy regarding deposits and prices is simple and explained to all new bridal customers: A deposit must be paid at the time of booking, with the balance due and payable at the time of the pre-wedding portrait photography session or two weeks prior to the wedding date, whichever event comes first.

Our deposits are non-refundable. In the event a bride has paid the balance due when required and then changes the date of the wedding, if we are still available we do not financially penalize her. If we are unavailable, then we will refund 50 percent of the money paid. This policy also holds true for those brides that cancel a wedding date at the last minute.

In the event that a bride has not paid the balance of her bridal package cost when required, we will not go to the wedding and she is so informed at the time of booking. The initial deposit is taken only to secure the date. It's a guarantee to her that we will not book someone else's wedding in her time slot. It is not a guarantee that we will attend her wedding. Only payment in full will guarantee this and she is so informed.

Payment of the Balance—Sometimes a bride will give you a deposit and then inform you she will pay the balance on the day of the wedding, after you have arrived. You may do as you see fit. We do not agree to such arrangements. There is too much chaos prevailing on the day of the wedding for you to also try collecting your money from the bride or her family. What happens if they again say they will pay you later? Holding firm keeps you on a business-like basis.

The Contract—Sometimes a bride will want a written contract signed, setting forth all of your obligations

and hers. The Nebs Co. in Groton, Massachusetts, has a standard photographic contract—Form 136-3—that you could use. The company can be telephoned at 1-800-225-6380. If you wish further information on photography contracts, we suggest you contact the Professional Photographers of America, Inc., 1090 Executive Way, Des Plaines, IL 60018. The telephone number is (312) 299-8161.

THE APPOINTMENT BOOK

Once you have booked a wedding, make certain you immediately record the wedding date and all of the pertinent information in your appointment book. It would be a financial disaster to book a wedding, be paid in full, and not attend.

Once Booked, Stay Booked—We have heard a number of stories of photographers who accept bookings, only to refund all deposits later and cancel because they have subsequently been hired to do more expensive weddings. This is totally unprofessional and should be avoided at all costs. Your reputation will suffer. You should ease the mind of the prospective bride by assuring her that, once you have accepted her deposit, you will stay booked. You should do this even if she does not bring the subject up herself.

Previews

Previews are nothing more than printed proofs—4x5, 5x7 or 8x10 prints—of the photographs you took at a wedding.

THE TRADITIONAL WAY

When all the exposed film has been developed, photographers generally have 4x5 proofs, or *previews,* made of all the photographs taken. This developing and proofing will generally take between one and three weeks, depending upon the lab used.

Once the proofs are in hand, you should screen them carefully. The poor ones, from a photographic standpoint, should be discarded. Those not acceptable from a printing standpoint should be sent back immediately to your lab with detailed comments on why they are unacceptable. Insist on correction before showing the prints to your customer. Your livelihood and reputation are at stake.

When all proof prints have been assembled, numbered and arranged in a logical order, they should be placed in some form of temporary preview book or binder and presented to the bridal couple for their inspection.

Some photographers will not permit the proof book to be taken off the premises and insist that the bridal couple review the book and make their final selection at the time it is presented to them. Other photographers allow the book to be checked out by the bridal couple for a designated period of time, such as three weeks, after first having secured an additional but refundable deposit to cover the loss or damage of the book and prints.

Whichever method you follow, or even if you choose a different one, you should have a definite policy and stick to it.

NEWER WAYS

Although it is considerably more expensive to make 8x10 proofs instead of 4x5 proofs, most of our bridal albums contain photographs that are in the 8x10 size. We do this because most brides order that size. It seems illogical to show a size we do not intend to sell and brides are not going to buy. In addition, most wedding pictures don't look their best as 4x5s. They are just too small.

For a while we used the following procedure for handling bridal proofs or previews: We would develop the film and then do a contact sheet of each roll of film. We would examine the contact sheets and print 8x10s of those photographs we felt best told the bridal love story. This usually amounted to a 50 to 100 percent greater number of photographs than the bride had selected for the bridal package at the time of booking. We would place these prints into a preview book and give it to the bride to take home for three weeks for review with her husband, friends and family. A refundable deposit would be required when the book was taken from our premises.

Although this procedure has its merits, it also has its flaws. What happens, for example, if you have selected the wrong images to print? If the final order for prints is exactly the quantity originally contracted for, what do you do with all of the excess prints? What if the bride keeps her preview book out for two or three months?

More importantly, by following this procedure one loses the great advantage of impact. Wedding photography involves a certain amount of emotional buying. Allowing the proof book to be taken home by the bride for a period of time permits emotion and impact to dissipate, with the result that sales suffer.

Photographers have explored alternatives and the modern trend is to do one of the following:

1. Allow no proofs to be removed from your studio and require the bride and any others concerned to come to you and place their order at the time the preview book is shown.

We have tried this method but, for us, it did not work. It was met with too much resistance.

2. Have a slide show. At the time you have your negative film developed, a number of labs throughout the country will, for an additional charge, also make slides of every photograph you took at the wedding. Then you simply call the bride and invite her, her hus-

band and anyone else she wishes along, to come and see their wedding in a slide show. After the show, the order for prints is taken.

This procedure has been successful for a number of photographers, but we have never used it.

HOW WE SHOW PROOFS

We have adapted a totally different way of showing proofs. We use an *Optilyser,* which is an electronic film viewer. You place a negative into the machine and it instantly allows you to view it as a positive on a television monitor.

Our procedure is to put through the machine all of the negatives we think show the entire love story and to record them all on video tape, with a musical background. The viewers are then invited to our studio for a showing of "their day." An order is taken at the conclusion of the show. We employ this procedure in about 80 percent of our preview presentations. In the other cases, when the bride and her mother specifically request it, we still present 8x10-inch paper proofs in an album.

Although the cost of the Optilyser is several thousands of dollars, since we have been using it our wedding orders have increased 50 to 100 percent. The machine is available through the Lucht Engineering Corp., Bloomington, Minnesota.

YOUR WAY

In beginning your career, walk before you run. Don't invest in a lot of expensive equipment until you get a taste for the market and business starts rolling in. You can always expand. Start with paper proofs, 5x7 or 8x10. At least you'll be able to sell some of the ones you will have had printed. Be careful to choose a lab that will number your proofs, no matter what size you decide to present. You do not want the task of matching proofs and negatives.

In addition, do not make the mistake of showing every photograph you took. Not all of them will be presentable or saleable. Show only your better images.

Whichever procedure you follow in presenting your proofs, set aside adequate time for reviewing them with the bride. You will usually require an hour or so but it will be time well spent. You will be laying a foundation for the final order.

Getting the Order

When the bride is ready to place her order—and you should have given her a deadline to do so at the time she took her preview book—insist that she make an appointment with you. As with the proofs, set aside sufficient time to review her entire order—approximately one to two hours.

Be certain you have on hand samples of all print sizes a bride may wish to order. In this way you may be able to discourage small-size sales. A 5x7-inch print will appear much better than one in wallet or 4x5-inch size and an 8x10 will, of course, look better still. In addition, have samples ready of all the wedding books you sell and swatches of all of the colors and fabrics such books come in.

There are a number of reputable wedding book companies throughout the country, each one offering a different look, style, finish and price. At present, we use books from both Art Leather Manufacturing Co., Elmhurst, New York, and Leather Craftsman Inc., Farmingdale, New York. The books from Leather Craftsman are the more elaborate and expensive of the two but well worth the money. Both companies will provide samples and prices.

Before sitting with a bride to take her final order, obtain from your lab the costs of spotting, retouching and special cropping of the wedding prints, in case she has questions about them.

Encourage the bride to bring others who may also wish to place orders. This will save you both a lot of time and effort.

At the time of ordering, you will often be asked if you will sell the negatives. Don't do it! This is part of your livelihood and if you sell your negatives you will have cut a large portion of your business.

GET A DEPOSIT
WITH THE ORDER

When taking the bride's order, you should require and receive a 50 percent deposit on all orders for prints beyond those in her previously selected bridal package, plus an additional deposit of 50 percent on any extra prints for family and friends. At this time you should have a clear understanding with the bride that the balance from the entire order becomes due and payable at the time the order is ready for delivery.

In other words, if a bride places her order, an order for extra prints for friends, and an order for the parents' albums, don't let her pick up just her bridal book and pay only for that. You must collect for the entire order. If you don't, you may be stuck with those extra prints and parents' albums, with no one claiming them.

Experience has taught us that, unless you follow this procedure, in spite of all arguments to the contrary, once the final bridal book has been placed into a bride's hands without payment in full for the entire order, your chances of collecting the balance will be slight.

SAFEGUARDS AGAINST
MISUNDERSTANDINGS

As a precaution, at the conclusion of taking her order, allow the bride to review your notes and have her initial the order. This will prevent a later problem if she forgets she ordered a

print or if a size is not as she remembered.

When the bride comes in to claim her final order, go over it with her in detail, examining every print. If everything meets with her satisfaction, have her sign a receipt acknowledging she received the wedding album and prints as ordered and in a condition satisfactory to her. This, too, will prevent future problems.

Despite this attention to business and communication safeguards, what you finally seek is a happy customer, one who will shout your praises. Do what you have to, within reason and good business practices, to accomplish this result.

A Final Word

Don't be discouraged by those who may tell you not to go forward with your photographic career. If you believe in what you are doing, have the toughness to stick with it and enjoy photography as we do, go for it! The world is full of people who never got anywhere because they were afraid of failure. And remember, there's no such thing as a success that is totally unaccompanied by occasional failures.

While you may not subscribe to doing weddings all of your life, it's a fabulous field to explore and work in—and a wonderful way of getting entry to other photographic work and fields.